TURNER

The life and work of the artist illustrated with 80 colour plates

GIUSEPPE GATT

THAMES AND HUDSON

Translated from the Italian by Pearl Sanders and Caroline Beamish

This edition © 1968 Thames and Hudson, 30–34 Bloomsbury Street, London WC1
Copyright © 1967 by Sadea Editore, Firenze
Reprinted 1984

Printed in Italy

Life

Joseph Mallord William Turner was born on 23 April 1775, in Maiden Lane, off Covent Garden, where his father William had a small barber's shop.

The child's precocious talent was soon apparent: his first drawings, mostly copies of magazine illustrations, seem to have met with considerable success, and his father's customers bought them for a few shillings. He went to school at Brentford, and when he was barely nine years old a local brewer asked him to colour some engravings (an activity to which Turner was to return later). These early successes were not without their lucrative aspect, and William Turner was encouraged to further his son's precocious talent. In 1788 he apprenticed him to Thomas Malton, a watercolourist of architectonic and topographical views. After about a year with Malton, Turner entered the Royal Academy Schools to study painting; he was then only fourteen years old. Meanwhile, his father had retired from his barber's shop and until his death in 1829 devoted himself entirely to helping his son. In 1793 Turner already had his own studio, where his father helped him with the preparation of his paints and canvases and undertook the domestic work; in this way he filled the gap in Turner's life left by his mother, a violent woman, who died insane. Turner was influenced by the kind of painting produced in Malton's studio and made a great number of architectonic and topographical drawings which were very much in the fashion at the time. He used to wander about the countryside and kept a·kind of traveller's notebook in which he made many precise drawings of the landscape, of castles and abbeys, which were so faithful to the original that they were later engraved and used to illustrate books of travel. He was often asked by the owners of country houses and castles to make precise and accurate drawings of their possessions. He was also working very hard at this time as a copyist (a very lucrative form of employment) and was employed by several architects to colour their plans.

There is no doubt that Turner's position in the mainstream of English watercolour landscape painting originated in these youthful contacts with the English countryside. In 1794 he met a patron, Dr Monro, who asked him, together with Thomas Girtin, another painter who had a decisive influence on Turner's art, to produce a series of watercolours taken from J. R. Cozens' travel sketches. A study of the works of this very accomplished landscape artist led Turner to consider landscape from a livelier and more imaginative point of view than he had so far shown in his topographical works. Meticulous copying of the subject (which was characteristic of topographical artists from Dayes to Hearne) made way for a more interpretative and imaginative approach which a technique such as watercolour could readily encompass.

At the age of twenty-one, Turner exhibited his first oil painting (*Bridgewater Sea Piece*, 1797) at the Royal Academy, where he was elected a member in 1799; in the same year he painted the famous work *Norham Castle,* considered by his/biographers to be the first of his official successes in the medium of watercolour. Turner did not, of course, neglect oil painting, but his first works in this medium were still no more than topographical studies. He soon abandoned this form, however, and turned to historical and mythological subjects (Turner's interest in epic themes was aroused during his journeys to Wales and the Isle of Wight). These paintings are classical in inspiration and very much influenced by Poussin and Claude Lorrain. It was at this time too that Turner painted the first of the seascapes, which were to prove such a fruitful source of inspiration throughout his life.

In 1802, he travelled abroad for the first time, visiting Paris and Switzerland. He found the Alpine landscape very impressive and romantic: in fact, he admitted that on the whole these countries were more beautiful than Wales and Scotland. In 1817 he travelled to Belgium and Holland and along the Rhine. When he was only twenty-seven years of age, he was made a Royal Academician (one of the youngest members ever). His fame, already well established, grew rapidly, and by 1819 a vast number of paintings had

George Dance
Portrait of Turner
(see p. 39)

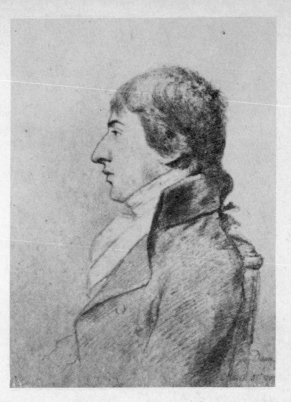

already been produced (it is estimated that Turner's total output was in the region of 20,000 works); among these early paintings there are some authentic and undisputed masterpieces, epic works, seascapes and landscapes. Before 1819 Turner had worked on the unfinished series of seventy engravings which he entitled *Liber Studiorum*, on the lines of Claude Lorrain's *Liber Veritatis*.

Turner's first journey to Italy took place in 1819; from his stay in Rome we have a number of sketches (about 1,500 pencil and. pen drawings) which are extremely interesting from a documentary as well as an artistic point

of view. Few oils were produced at the time of this first visit to Italy, however. He returned to Italy on another four occasions between 1819 and 1840 and was able to visit almost all parts of the country: Venice, Turin, Como, Genoa, Milan, Bologna, Rimini, Orvieto, Ancona, Florence, Naples and Viterbo.

Very little is known of Turner's private life and there is conflicting evidence regarding certain aspects of his character: his withdrawn and intractable temperament prevented him from having many friends, and he never married. After his father's death in 1829, this cantankerous, fat little man became more and more misanthropic and solitary, evading all the social relationships and connections which his great and constant success could have brought him.

Turner's passion for long journeys abroad never left him. His eccentricities, his proverbial avarice (although this has been denied by some people who knew him), his paradoxical and suspicious conduct, gave rise to many false rumours, among them that he was insane (the publicity unleashed by Walter Thornbury's biography in 1861 caused him great harm). John Ruskin, one of the few who were able to observe Turner at close quarters and visit him as close friends, denied the truth of these rumours. The last, fully active, years of Turner's life were spent at Chelsea where his identity was disguised under the name of his landlady, Booth. He was found by his housekeeper, Miss Damby, and taken home shortly before his death.

He died on 19 December 1851, at the age of seventy-six, an embittered and gout-ridden old man. He left a legacy of £140,000 in securities, two houses in London, and a collection of his works whose value is inestimable. His will, which bequeathed all his property to old and poor artists and his art collection to the State, was contested by his relatives and annulled. He is buried in St Paul's Cathedral, beside Sir Joshua Reynolds.

Works

Turner's first manner is very much conditioned by the English pictorial taste of the second half of the eighteenth century, with its recurrent themes of landscapes, ruins and views of towns, and its style of topographic and illustrative drawing, closely imitating reality.

Although Turner's early work was imbued with all the characteristics of the style of the period – as Focillon has recently confirmed, stressing the sovereign importance of Turner's position within the ambit of conventional, touristic English painting – his precocious and amazing personal gifts were not long in coming to light and were greatly appreciated by connoisseurs and the general public alike, as is shown by his election to the Royal Academy at the early age of twenty-four. Besides, Turner's adherence to the dominant manner of the time, whether in the form of classicism, or of the Dutch landscape tradition (harshly censured by Sir Kenneth Clark, who saw in the early Turner only an eclectic imitator), was of very short duration. In a series of watercolours executed in 1797-9 it was possible to discern already that Turner's conformity to the tradition and taste of the time was related more to subject matter than to style or technique. And in this connection it is no accident that the supporters both of the ' sublime ' and of the ' picturesque ', each of which factions contested Turner's adherence to their preferred manner of painting, later blamed him equally for his departure from the painting of close observation. This was around the year 1800.

From the point of view of technique and execution, Sir Joshua Reynolds gave Turner some advice which was to be of the utmost importance to him, namely, that he should not confine himself to copying the masterpieces of artists of the past, but should make use of them as stepping-off points for his own work. It was this advice which enabled Turner, in his vast numbers of epic and historical works especially, to become the master of a technique which was not only outstanding in its exceptional skill, but also

contained completely original elements. Although the most famous and celebrated Turner is the Turner of the 'landscapes of nature', and his copious production of historical paintings was executed during the first decade of the nineteenth century, he never completely abandoned epic painting and went back to it at various times throughout his life, right up to 1850, the year before he died; in fact, his last paintings were on the classical theme of Dido and Aeneas. The reason for this devotion to epic painting is that Turner considered it a means of expressing, through conventional subjects, evolving formal values which were absolutely original and modern. There is no doubt that his true originality and modernity are most apparent in the paintings of highly conventional subjects, containing anecdote and action. We need only consider the famous *Snowstorm: Hannibal and his Army crossing the Alps* (*pls 20-2*), exhibited in 1812, where the subject is used merely as a pretext for the introduction of technical and stylistic innovations and where landscape is conceived in an original and disconcerting light. We know too that, even before this work was painted, the first of the great series of historical subjects, *The Fifth Plague of Egypt,* exhibited in 1800, took its inspiration from a blizzard among the Welsh mountains.

If Turner's interest was in the reality of nature, it is not surprising that even within the framework of a historical painting he gave his attention mainly to the landscape, and essentially to that aspect of nature where the atmosphere was of supreme importance, as it conditioned reality to its ambient mood. He therefore concentrated on the intensity of light, on clouds, on the movement of the sea, the action of the wind and rain. This explains why ultimately Turner's genius was realized with greater immediacy in those works which are not subject to the restraints of content. It is for these works that he is considered to be the artist who comes closest to Ruskin's ethic of 'fidelity to nature', whose painting is an exemplary and exhaustive application of that ethic (as Ruskin himself has not failed to point out), although caution must be exercised in exactly interpreting this concept: for one thing, the idea of naturalism was

understood in quite a different sense from the interpretation later given it by the French impressionists.

It was this very freedom of Turner's conception of the art of painting (together with his individual technique and lack of preconceived notions, enabling him to introduce into the conventional forms of historical painting the first glimmerings of a preoccupation with modern attitudes) which brought upon the artist so much censure and hostility on the part of the official critics of the time: from Hazlitt, who wrote in *The Sun* in 1816 to condemn the empiricism of painting trees blue and yellow to produce an effect of green, to Hoppner, who called Turner's paintings coarse, rough and disorganized. They were defending a well-established and refined taste, which the painters of ruins, the topographic artists, the arcadian painters of rural and historical scenes, had contributed to create and propagate, and which was especially devoted to the norms of exactitude and faithful adherence to the truth (even if this was an aesthetic ' truth ', that is, a mannered and idealized truth). This whole attitude was called in question by Turner, who was not concerned with minutiae and refinements, but adopted violent and sometimes complementary colours (to obtain the greatest degree of luminosity) so that the foreground plane was readily dissolved into a simple patch of colour. To show how one could ' see ' through great masses of light and shade was a basic theme of Turner's art: in this he not only anticipated certain attitudes of the impressionists towards what is ' seen ', but came to create the great historical synthesis between the Dutch landscape tradition and the universal grandeur of classicism. Turner's painting – in all its periods – did not undergo revisions or rethinkings; after the youthful period of his formation, which can be considered at an end by about 1800, his style evolved according to a rigorous, coherent and continuous line of development, in which the lessons of artists of the past combine with his own impassioned and minute study of nature to produce an art of extreme

Overleaf: Edinburgh Castle (see p. 31).

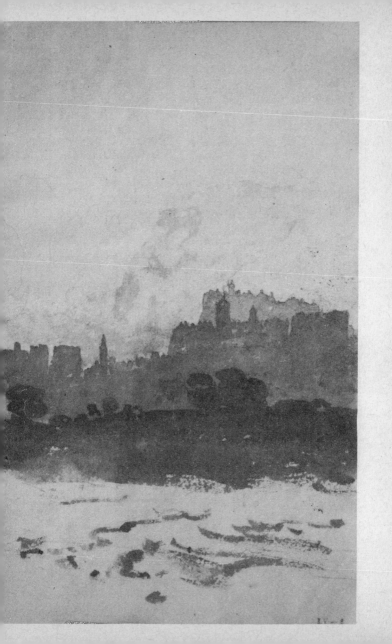

technical accomplishment, able to capture and treasure every effect light can produce, even to the extent of surpassing the bounds of what is 'true to life', and to render both the misery and the Pan-like joy of the human condition as it is related to the immensity of nature. It is for this reason that Turner's drawing never appears or functions as a means of translating the image, or as a graphic idea which, as it were, stands above the image; but the very form of the drawing seems to be derived and to grow out of the images themselves.

Just as drawing is an exigency of form, so colour is a quality of form: watercolour, which by its nature incorporates the brilliant transparency of light and the shifting fluidity of water, subjects Turner was to paint again and again; and oil, which is able to make objects glow and become alive and responsive to the aesthetic idea of the natural image which the artist has created for himself.

After the topographical beginning, the decisive direction Turner's painting was to take became apparent around 1795. Two factors which had a determining influence were, firstly, the discovery of J. R. Cozens (studied by Turner together with Thomas Girtin in the collection of water-colours belonging to the famous collector and art lover, Dr Monro) and secondly, Turner's journeys to Wales and the Isle of Wight. Through Cozens, who is probably the most important English watercolourist, Turner was initiated into the 'picturesque', a form of painting whose greatest theoretician – as well as greatest exponent – had been Alexander Cozens, and which derived from seventeenth-century Italian art, where the problem of an aesthetic selection of the values of nature, rendered with a particular technique, had been studied by Marco Boschini and Salvator Rosa.

The concept of the 'picturesque' (a key concept to the comprehension of Turner, even though in his case, as we shall see, it took an individual form) presupposes a selection of the themes of painting, in the sense that not all aspects of nature can be of equal interest to painters who grow up in certain periods of history. The artist will select those aspects of nature which he finds most interesting and most

apt to be expressed in the form of painting. It is important for the artist to study and be aware of the masters of the past, in order to be able to single out those aspects; the 'picturesque' – as Argan has defined it – is a historically-based form of artistic values in which every effect is achieved by means of forms and ideas which have already been realized in painting. It thus becomes related to the concept 'beautiful', and equated with it. Since the beautiful of the picturesque is the 'beautiful' of nature, the landscape of a 'picturesque' painting will not be an urban landscape – as this kind of landscape appears uniform, artificial and lacking in space and varied perspective, apart from the fact that it also lacks a pictorial tradition – but it will be a rural landscape, where the qualities of nature are revealed in their manifold significant and alluring aspects. Of course, the interpretation of the landscape in art will be subject to a process of constantly attributing aesthetic qualities to the raw material of nature, which is selected according to value criteria, applicable only to certain salient aspects of nature. This is why the painter 'teaches one to see' those details in nature which are already art (it is in this factor, as Argan has pointed out, that the difference between the French or Italian conception of art and the English convention is to be found: whereas English painting brings an element of art to nature, Italian and French painting translate the qualities of nature into art; and it is in this that their 'naturalism' consists).

A corollary to these principles has a direct repercussion on the artist's technique: the picturesque has to be executed with bravura, taking little account of detail, and a broad, rapid brush stroke will lend significance to the variety of nature and produce, in its immediacy of execution, an immediacy of emotion. The subjects of the paintings also follow a fairly rigid schematic pattern: the landscape is gradated in successive planes, as in a great stage setting where, arranged between the foreground (tree trunks, stones, tufts of grass) and the horizon, are the 'picturesque' themes in all their varied and conventional repertoire (waterfalls, rural objects, crumbling bridges, ruins, lakes, twisted trees), shown as they appear under the action of air and

light according to the distance between one plane and another. Furthermore, the atmosphere pervades all objects with its own extraordinary and powerful effect, enveloping, permeating and dissolving the solid masses in the sky.

Notwithstanding his respect for this traditional manner, if we were to define the nature of Turner's spatial dimension, we might say that his space is neither a real space nor an illusory space; in fact, it is not illusory just because it is not real (in the sense of ' empiric '). It is probably a ' memory space ' (as it is to some extent in Hogarth), space as it has emerged after passing through the silent filters of memory, the more real and present as its originating emotion was the more intense and poignant. The same might be said also of time, which is rendered on the canvas with a brevity proportional to the intensity of the moment of the phenomenon's manifestation. A work such as the famous *Rain, Steam and Speed* of 1844 (*pls 83-4*) is a case in point, and there are other equally typical examples. We know too that much of the work produced as a result of Turner's travels grew out of a later elaboration of colour notes and summarily jotted-down sketches. And it was this same process which later, in the final state of the paintings, produced an impression of something which hardly appeared to have been ' seen '; this freshness of vision breathed new life into the English landscape tradition, at least compared with what had been done before the time of Constable.

This space-time qualification is directly related to the problem of light; Turner's view of light tended continually to show light as a pure and absolute element, and the space within which objects had to be contained as a limitless, dazzling space, freed from any restraints of chiaroscuro and analysed through the medium of light. And it was to this concept of space-light that Turner subordinated the traditional and conventional rules of perspective, setting out to show the distance between one object and another by means of a greater or lesser concentration of light, which could break up outlines, fuse solid objects and re-absorb them in the infinite depths of the atmosphere.

If Gainsborough is the greatest interpreter of the English picturesque tradition, it was through the intermediary of

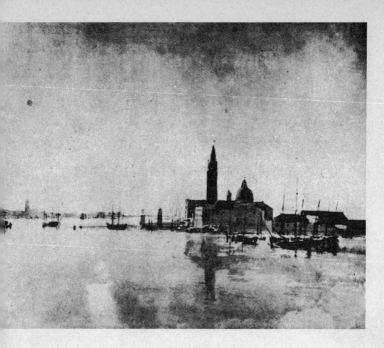

San Giorgio from the Dogana (see p. 30)

Cozens that it came into Turner's experience. But in spite of the influence of the current manner of painting and Turner's allegiance to classical modes of the 'picturesque', there is no doubt that – as has already been shown, and will be seen again later – his attitude places him far in advance of the English tradition of the second half of the eighteenth century, in all spheres of painting. From Thomas Girtin (a most precocious genius, considered by Herbert Read to be even greater than Constable and Turner), Turner acquired his taste for travel, his prodigious watercolour technique and his modern conception of landscape painting, based on an equilibrium between space and colour, although at a very early stage he discarded the 'topographical' emphasis which still informed Girtin's landscapes.

From his journeys to the Isle of Wight and to Wales came Turner's discovery of an epic vocation which led to the production of his masterpieces of historical painting. In this prolific field, Turner was influenced by the example of artists such as Claude Lorrain. From Claude, Turner assimilated the restrained and perfect forms of classicism, the grandiloquent gestures of historical or legendary figures, expressed partly by means of juxtapositions of light and shade against the vast backcloth of nature. History had become a matter for serene and detached contemplation, the representation of motionless events whose drama has been extinguished for ever. This is what Argan defines as 'moral classicism', a style very close to Poussin and certainly at the opposite pole to the typically Italian painting of someone like Salvator Rosa (though his art was very much in the fashion among all English eighteenth-century art collectors), where all is vibrating, full of action and movement, where men are still seen in action, in relation to nature and even to history itself, both of which are made subordinate to the fate of the characters in the drama. But if Turner's historical works show that he has absorbed the stagey backgrounds and the theatrical attitudes of the characters represented by Salvator Rosa, it is equally certain that Turner did not wish to evoke or glorify a lost and lifeless history, and even when employing archaic forms he strove to express a living, modern conception of history in which man is responsible for his own destiny.

In his historical works as well as in his landscapes, the problem of light is the nucleus of Turner's painting. The problem is first treated in the watercolours, because by their nature they do not have to be subjected to a rigorous, schematic form of composition: the essential features of the landscape are noted freely, and the artist's main purpose is to maintain intact the vivid immediacy of the moment of contact with nature, and transfer to his canvas an authentic impression of his immediate perception of reality. And since, among the many factors in nature, perception must first measure itself against light, Turner submits each object to the modifying action of light, analysing the rapidly changing atmospheric fluctuations and treating every land-

scape, every variation, with masterly technique, in spite of the fact that the volumetric masses and solid bodies would seem to call for a static treatment. Although the principal and final object of Turner's enquiry is pure light, he examines it indirectly by analysing the modifications light brings to objects; it is only after this intermediate study that he treats light itself as an absolute entity.

Ruskin has written of Turner's luminism, pointing out that his vision of colour is the exact opposite of Rembrandt's; while Rembrandt tends to a ' descending ' colouring, where light is used indirectly in order to be rejected and dissolved into shadow, Turner's colouring is ' ascending ' – it is resolved, through a progressive purification of the various degrees of light, into a light which is all-embracing. In substance, therefore, as a logical conclusion to his investigation, Turner poses the problem of pure and absolute light as an abstract theme; the more effectively formulated, the more it transcends the limitations of a naturalistic convention, however refined.

This anxious search for luministic effects, to the exclusion of all others, has a powerful effect on the form: outline becomes progressively less important and the colours tend to fuse. It is apparent, however, that in spite of the filter of memory and Turner's thorough and exhaustive experimentation in effects of atmosphere, the prime source of his preoccupation with light is to be sought in the impressions he brought back in his youth from the Alpine landscapes of Switzerland; here the overwhelming grandeur of nature merges into a rarefied and crystalline atmosphere which emphasizes the transparency and sparkling purity of every spot of colour, while simultaneously performing a synthesis of all the details of the landscape. These impressions resulted in the so-called ' Alpine manner '; the source of whose inspiration lay in a ' nature which is real ' and a ' nature which is re-lived ' in memory and the imagination; a nature, therefore, which has been idealized.

When the epic side of Turner's genius is in the forefront, those masterpieces, his storms, come into being. In them the artist's temperament and the phenomenon of nature are fused in a single rendering and a single revelation; the

painting is burning, agitated and lacerated, violent and splendid as a tempest in nature. At this point it should not be forgotten that this method of procedure in investigation, starting from the original fact of experience – that is, of pure sensation – and placing this fact at the source of knowledge, derives from a profound sensuous conception of reality which without doubt was a determining factor in Turner's artistic development.

Immersion in nature, which took the form, in the works in the Alpine manner, of an impulse to possess and exalt a resplendent and enchanting element, became modified in the works produced after 1819 (those, in fact, coinciding with Turner's first journey to Italy) as he came under the influence of the very different Mediterranean landscape: here nature appears in a calmer and more peaceful aspect, with less violence and movement, as if in an imperceptible fusion between the vision of the eye and the dream vision of the imagination, in a contemplative rhythm closely akin to the attitude of a Keats or Shelley.

This parallel with English poetry is not at all far-fetched. It is, in fact, extremely difficult to approach Turner's painting, especially his painting after 1819, without taking into account the attitudes and tastes of the romantic movement. A lyricism animates and breathes through Turner's painting, not only in the choice of the subject matter, but also in manner and technique: colour is deformed and sensitized until it becomes sublimated, and inert matter becomes an incorporeal and ineffable vehicle of sensation.

Besides, such a strong and active link between poetry and painting was not new in the history of English art. Hogarth had already upheld its validity, even if his treatment was more episodic.

In Turner, however, the literary element plays a much more important part, investing the very substance of the painting and rarefying the narrative element until it becomes a lyrical hypothesis, a mental and emotive state merging into so rarefied an image that it becomes dissolved beyond our sphere of experience, although it comes directly out of it.

It is no accident that Turner's painting has been defined as 'natural sublime', this definition being intended to

convey an exalted state of comprehending and rendering nature, quite opposed to the concept of 'spirituality' and different also from the so-called 'classical sublime' of Cozens and Wilson. It is on this basis that one can state that, with Turner, the tradition of classical English painting (and implicitly, Dutch and Flemish painting as well) reaches the extreme limit of its expressive possibilities.

If Turner's fame was already at its height in 1819 (his art having already superseded all the narrow limitations of English painting of the time, from romanticism and the neo-Gothic stylization of Blake and Fuseli to the classicism of Reynolds), he had not yet produced the masterpieces inspired by his visits to Italy, especially the wonderful paintings of Venice.

In these paintings, all glittering with light, the influence of Canaletto and Guardi is quite obvious; but Turner's study of light effects took him right back to the original sources of Venetian painting, whose greatest master was Titian. His painting becomes impalpable, a thing of air and luminous vapours, in a range of jewelled colours. Landscape no longer exists as a subject in itself; it is no more than a pretext for the rendering of pure rhythms of light, transparent and reverberating: glowing splendour and ashy dust particles. The 'natural sublime' has reached its climax, and Turner's investigation of light can go no farther. The years 1819-40 are Turner's so-called 'middle period', when his art attained the sureness and strength of maturity and the subject of his investigation into light became clear.

To this period belong, as well as the incomparable Venetian marine paintings, such masterpieces as the series of *Interiors at Petworth* (*pls 37-41*), *Fire at Sea* (*pls 46-7*), *The Burning of the Houses of Parliament* (*pls 48-50*), *The Slave-ship* (*pls 67-8*) – about which Ruskin wrote that if he had to make Turner immortal with only one painting, this is the one he would have chosen – *Ulysses Mocking Polyphemus*, etc.

Meanwhile the public was turning from Turner's evanescent and airy images, made of pure light, and with blurred contours, and moving towards the clear, volumetric solidity

of Constable's art. At this middle period of his painting, when he had reached the summit of his achievement, Turner was already made aware of the painful hostility which awaited him. And, while Constable's art is based on an absolute and instinctive seeking after clarity, Turner reacted desperately to this denial of his whole aesthetic achievement, by making the image even more rarefied until it became a sort of abstract figuration, precious and 'sublime', and treated with an ever freer, more masterly technique.

This polemical 'modernism', in which the 'modern sublime' finds its realization and which depends upon the essential requirement of a classical culture, is exemplified in the famous painting *Rain, Steam and Speed,* of 1844 (*pls 83-4*). The rushing train which appears and disappears through squalls of wind and rain is like the myth of an emerging new world, antagonistic to nature, at which Turner gazes with despair. It seems that there is nothing left to discover in nature: every vision has been reduced to the expression of a deep inner world of the artist, in which he takes jealous refuge. In life too Turner runs away; he hides under false names. In the works of his late maturity this drama became especially acute: every form was broken up in the movement of light and the changing seasons, every volume was dispersed and dissolved in the fluctuating and impalpable whirlwind of a light which had now become a myth and a symbol of the myth. The works of this period reveal a tragic picture of Turner's personal life; the cosmic upheavals are unleashed in their ultimate fury, and these paintings take their place among the most critical manifestations of European nineteenth-century culture.

Writing in *Modern Painters* about 'Turnerian Mystery', Ruskin discourses most illuminatingly on the genesis of Turner's art: '[Some men] see more than others; but the consequence of their seeing more is, that they feel they cannot see all; and the more intense their perception, the more the crowd of things which they *partly* see will multiply upon them; and their delight may at last principally consist in dwelling on this cloudy part of their prospect, somewhat casting away or aside what to them has become comparatively

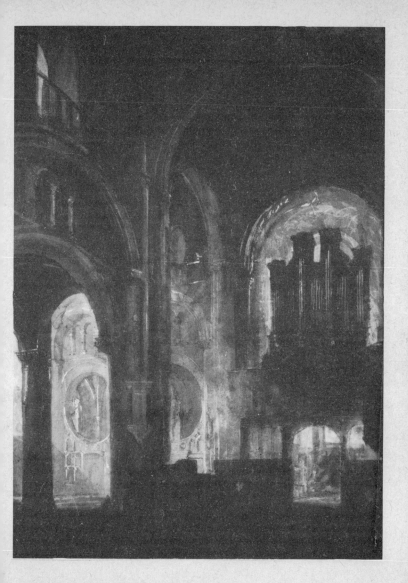

Interior of Christ Church, Oxford (see p. 28)

common, but is perhaps the sum and substance of all that other people see in the thing, for the utmost subtleties and shadows and glancings of it cannot be caught but by the most practised vision.'

The roots of Turner's art lie in the first contact with reality. As he has shown us, this is not an inferior form of awareness, but is in itself able to yield fully the values of form. And in so far as perception is awareness, it may be trained and increased through the continuous exercise of encompassing the image from the point of departure of the perceived fact.

It is for these reasons that, having surpassed the emotive and contemplative origins of his art, and gone on to expound a concept of painting as an investigation into that which is most intimately 'real' and objective in nature, Turner may be considered the first 'modern' painter of Europe.

Turner and the Critics

When Turner was still a student at the Royal Academy Schools, one of his teachers advised his father not to let him take up painting as a professional career, since his first efforts showed so little talent and a complete lack of intelligence. Referring to the predilection for light colours and broad expanses of wind-driven clouds shown by Turner in his earliest paintings, critics made fun of the 'whiteness' of his canvases, which William Hazlitt, with wounding sarcasm, described as 'pictures of nothing, and very like'. And since some of his paintings were so formless that, we are told, he had to indicate which was the top and bottom, so that they should not be hung upside-down, Hazlitt declared that Turner 'delights to go back to the first chaos of the world... all is without form and void', and condemned what he called Turner's 'empirical' use of blue and yellow in order to obtain green.

The famous *Snowstorm* was defined as 'soapsuds and whitewash'; and, confusing criticism and gossip, Sir Walter Scott – who was, however, an admirer of Turner's work – wrote that he was as mean as he was talented; he would do nothing without money and for money he would do anything. When Turner was twenty-eight years old, in 1803, he was accused in *The True Briton* of being a charlatan who had 'debauched the taste of the young artists'. And, about ten years later, Sir George Beaumont repeated similar accusations, adding that it was a technical error to make oil painting resemble watercolour, since 'in attempting to give lightness and clearness, the force of oil painting has been lost'.

Hoppner likens a Turner room to a 'vegetable stall' and, again in 1846, a caricature of Turner appeared in *The Almanack of the Month* showing the artist in top-hat and tail-coat, in the act of daubing a canvas with a large dripping brush, soaked in a bucket on which is the word 'yellow'. This form of abuse of Turner reached its extremity in Walter Thornbury's biography, *The life of J. M. W. Turner*,

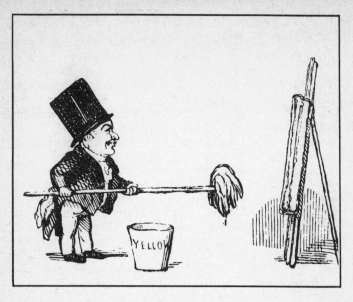

Turner painting, caricature (see, p. 39)

which was published in 1861. This showed Turner as a licentious man, greedy for money and the epitome of vulgarity, miserly, hot-tempered and ambitious. Luckily for Turner, Thornbury's accusations were soon shown to be unfounded, and were publicly denounced in 1862 in scholarly periodicals like *Athenaeum* and *Quarterly Review*. Thornbury was declared a 'circulator of falsehoods', 'a Paris chiffonnier, who goes about with his basket and picks up every bit of filth and tinsel that comes in his way'.

Nothing daunted, Thornbury published a second edition of his biography in 1877. This brought not the slightest modification to the general picture of Turner produced in the earlier edition; and because most of the people who had direct knowledge of Turner's life and could have replied to this renewed attack were no longer alive, Thornbury remained Turner's official biographer until 1939, when the Clarendon Press, Oxford, at last published A. J. Finberg's *Life of J. M. W. Turner;* this work, while not

exactly a biography (consisting for the most part of evidence on matters of gossip), did much to counter these libellous attacks on Turner.

In general, even those writers who admire Turner have never really grasped the full significance of his work, even though they have praised it; perhaps this is because they have given undue importance to its literary aspect, which is certainly important, especially for a historical study, but is far from being the only significant factor. For the most part they heap indiscriminate praise upon him but do not go far beneath the surface. John Williams, writing in *The Morning Post* in 1809, expressed serious doubts (as has Kenneth Clark) on the subject of historical painting (which was, however, appreciated by Sickert), but praised Turner unconditionally as a landscape artist; and Thomas Lawrence (one of his very first admirers) said that Turner was ' without doubt the foremost landscape painter in Europe '. In a similar vein are the writings of J. Burnet and P. Cunningham (*Turner and his Works,* 1852), R. N. Wornum (*The Turner Gallery,* 1859), W. C. Monkhouse (*The Turner Gallery,* 1862), P. G. Hamerton (*Life of Turner,* 1879).

Once critics adopted a more scientific approach to their analysis; some penetrating observations were made, like those of D. S. MacColl, who said of Turner's drawing that it was not a rhythm imposed on objects from outside but ' an eye ', fixed on the very principle of their construction (*Nineteenth Century Art,* 1901, and ' Turner's Lectures at The Academy ' in the *Burlington Magazine,* 1908), or some fearful howlers, like that of Fry, who excluded any naturalistic origin from Turner's painting.

Ruskin has written with great insight of Turner's art, even though he too often abounds in eulogy, in: *Harbours of England* (1856) and *Notes on the Turner Gallery at Marlborough House* (1856) culminating in *Modern Painters* (1843-60). The emphatic tone adopted by Ruskin, although alternating with observations of great penetration, has made it very difficult to arrive at an impartial evaluation of Turner's art, and to understand its true significance.

It is from Turner's colleagues that we learn much of interest, especially in connection with his artistic theories.

Turner's closest rival, Constable, said in 1828, 'Turner has some golden, splendid, beautiful images', and he grasped one of the fundamental directions of Turner's art when he wrote, 'Turner is becoming less and less faithful to nature'.

In a famous letter to Sir Coutts Lindsay, the greatest of the French impressionists (Renoir, Pissarro, Sisley, Monet, and others) wrote that their object was 'to bring art back to a scrupulously exact observation of nature, to devote ourselves passionately to reproducing form in movement as well as the fleeting phenomena of light', and added that they 'could not forget having been preceded in this path by the great master of English painting, the illustrious Turner'.

In 1858, Delacroix wrote that 'Turner and Constable are true reformers. They have moved out of the path laid down by landscape artists of the past. Our school, which now abounds in men of talent in this genre, has greatly profited by their example'.

In the twentieth century, studies of Turner have become more thorough, less reliant on anecdote and somewhat more scientific. Some essential reading matter is listed below in chronological order:

F. Wedmore, *Turner and Ruskin*, 1900; C. F. Bell, *A list of the works contributed to public exhibitions by J. M. W. Turner*, London 1901; F. T. Gill, *Turner*, London 1904; T. A. Cook, *The watercolour drawings of J. M. W. Turner in the National Gallery*, London 1904; W. L. Willie, *Turner*, London 1905; A. Wherry, *Turner*, London 1906; W. G. Rawlinson, *The engraved work of Turner*, 1908; C. Holroyd, *The watercolours of J. M. W. Turner*, London 1909; A. J. Finberg, *Aquarelles de Turner à Farnley Hall*, 1912; T. Ashby, *Turner's visions of Rome*, London 1925; A. J. Finberg, *In Venice with Turner*, London 1930; C. Mauclair, *Turner*, Paris 1939; R. B. Beckett, 'Kilgarren Castle: a link between Turner and Wilson' in *The Connoisseur*, CXX, No. 505, 1947; H. F. Finberg, 'Turner's views of Caernarvon Castle' in *The Connoisseur*, CXXIX, No. 525, 1952; T. S. R. Boase, 'Shipwrecks in English Romantic Painting' in *Journal of the Warburg and Courtauld*

Institutes, XXII, Nos 3/4, 1959; P. Willetts, 'Letters of J. M. W. Turner', *British Museum Quarterly*, XXII, Nos 3/4, 1960; P. Quennell, 'Petworth', in *L'Oeil* 83, 1961; J. Rothenstein, *Turner;* A. Stokes, *The Art of Turner in Painting and the Inner World*, London 1963; J. Gage, 'Turner and the Society of Arts' in *The Journal of the Royal Society of Arts*, CXI, 1963; L. Gowing, 'Turner's "pictures of nothing"', in *Art News*, 1963; J. Ziff, 'Proposed Studies for a lost Turner Painting' in *The Burlington Magazine*, July 1964; U. Kitson, *Turner*, Blandford Press, London 1964; J. Gage, 'Magilphs and Mysteries', in *Apollo* LXXX, No. 29, July 1964; J. Gage, 'Turner and the Picturesque' in *The Burlington Magazine*, CVII, Nos 742-743, January-February 1965; U. Butlin, *Turner Watercolours*, London 1962 and 1965.

In March 1966, the Museum of Modern Art in New York held a great Turner exhibition (*Turner: Imagination and Reality*), for which Lawrence Gowing prepared a full catalogue containing ninety-nine of Turner's most representative works.

C. R. Leslie: Sketch of Turner (see p. 39)

Notes on the Plates

1 Portrait of the Artist when Young. Oil on canvas, 73×58 cm. London, Tate Gallery. Painted before 1800. Turner's physical appearance and his extravagant personality gave rise to a series of satirical portraits of him, as well as to a great deal of slander and libel. But although there are many caricatures of him in existence, done either by contemporary painters or by himself, this is the only true self-portrait which survives. It is an interesting painting because it is one of Turner's earliest pictures in oils, which already reveals him as a gifted draughtsman, and because it is one of the few portraits that he ever painted. The dark background and the central placing of the figure reflect the influence of the classical painting of the seventeenth and eighteenth centuries.

2-3 Shadrach, Meshach and Abednego in the Burning Fiery Furnace. Oil on canvas, 90×70 cm. London, Tate Gallery. The exact date of this painting (shown for the first time in 1832) has never been established, but it is obviously one of Turner's early works. His adherence to the poetic principles which he adopted in 1801 – the use of compact masses of light and shade – is evident here. Nevertheless it is impossible to decide whether he is looking back to classical art during this period, or to Dutch art. This painting is certainly contemporary with *Rembrandt's Daughter* (Knoedler collection, London).

Interior of Christ Church, Oxford, 1800 (illustration in black and white p. 21). Watercolour, 76.5×54 cm. London, British Museum.

4-5 The Shipwreck: Fishing-Boats endeavouring to rescue the Crew, 1805. Oil on canvas, 172×241 cm. London, Tate Gallery. This is a very famous painting; though Turner painted it when he was quite young it shows extraordinary mastery of expression and perfect command of technique. Turner was familiar with the fury of the high seas and his painting was tremendously influenced by this. The realism of this storm-tossed sea and the shipwrecked sailors desperately trying to survive make this one of the masterpieces of Turner's youth.

6-7 Windsor, from Lower Hope, 1805-10. Oil on canvas, 31.5×73 cm. London, Tate Gallery.

8-9 Eton, from the River, 1805-10. Oil on canvas, 35.5×66 cm. London, Tate Gallery. This painting and the preceding one, *Windsor, from Lower Hope*, and the two following, *House beside the River, with Trees and Sheep* and *The Thames near Walton Bridges*, were part of a series painted between 1805 and 1810. They

are small, impromptu sketches, extremely spontaneous and clear. Their technique is very close to that of the watercolour, at which Turner excelled.

10-11 House beside the River, with Trees and Sheep, 1805-10. Oil on canvas, 97×114 cm. London, Tate Gallery. In a note on this painting, Sir John Rothenstein recalls that Ruskin, having spent a whole day trying to locate the exact spot from which Turner had painted, was obliged to give up the search with the comment that the rascal had made the Thames flow in the wrong direction. In drawing attention to the elegance and spontaneous harmony of this painting, Rothenstein also quotes a comment by D. S. MacColl to the effect that Turner's composition is not a rhythm imposed on objects from without; his eye is firmly focussed on the basic principle of their construction and their individual rhythm. Turner succeeded in giving life to trees and rocks from the inside.

12-13 The Thames near Walton Bridges, 1805-10. Oil on canvas, 36×74 cm. London, Tate Gallery. The firm composition of this painting and the dense placing of the objects differentiates it from the other paintings of this period. The Walton Bridges are in the background. On the left a house and a clump of trees and undergrowth are reflected in the calm waters of the river. Two other pictures of the bridges at Walton, painted a year earlier, are quite different from this one not only in composition but also in technique and the interpretation of the scene. In the earlier two paintings the influence of Dutch landscape is manifest, whereas here Turner seems to anticipate the visual values of the impressionists, from Monet to Sisley; his mature paintings do not, however, share many similarities with their works.

14-15 Richmond Bridge, 1808. Oil on canvas, 90×120 cm. London, Tate Gallery. This most admirable painting is one of Turner's youthful experiments: it has a strongly idyllic flavour, typical of the eighteenth century and particularly reminiscent of Claude Lorrain whom Turner admired and studied with the secret wish of emulating and perhaps rivalling him (in his will he left two paintings by Lorrain to the government with the proviso that they should be hung in a room with two of his own paintings).

16-17 The Fall of an Avalanche in the Grisons, 1810. Oil on canvas, 90×120 cm. London, Tate Gallery. This is almost certainly painted from life. We know that Turner painted more than one picture which drew its subject from the feelings he had experienced during raging Alpine storms. The theme, nature unleashed against defenceless man, was to recur frequently. In 1810 it was shown in Turner's gallery. The following comment appeared in *The Sun*: ' In Mr Turner's gallery there is a rich display of taste and genius... the fall of an avalanche in the Grisons is not in his usual style, but is no less excellent. ' The realism of the scene and its interpretation give it a particularly intense dramatic quality.

18-19 Abingdon, Berkshire, with a view of the Thames - morning, c. 1810. Oil on canvas, 100.5×128.5 cm. London, Tate Gallery. This is a carefully-composed painting, showing the strong contrast between the solid colours of the foreground and the delicate shades of the dawn sky behind.

20-2 Snowstorm: Hannibal and his Army crossing the Alps, 1812. Oil on canvas, 145×236 cm. London, Tate Gallery. The theme of puny man in confrontation with the immensity of nature and the fury of the elements recurs frequently in Turner's paintings. In this painting, exhibited in 1812, Hannibal's formidable army is reduced to insignificance by the majesty of the Alpine scenery and the storm brewing in the turbulent sky. Besides being a typical example of Turner's thematic interests, this painting is important because it shows how Turner subordinated the historical subject to his interpretation of the landscape, and in this case reduced the historical message of the painting to the merest pretext. We know in fact that the inspiration for this picture came from a real snowstorm which Turner experienced whilst travelling in the Swiss Alps.

23-4 Frosty Morning, 1813. Oil on canvas, 113×174 cm. London, Tate Gallery. This painting was welcomed favourably by critics when it was first exhibited at the Royal Academy in 1813. Although it was presented with a quotation from Thomson's *Autumn*, it was inspired initially by hoar-frost seen by Turner in Yorkshire. The gentle impression of the picture could possibly have been due to literary suggestions, but it is most improbable that these would be as strong as the suggestions aroused by nature itself. In the style of this work can be traced the influence of Turner's predecessors, Poussin, Van der Velde, de Cuyp and Claude Lorrain.

25-7 The Decline of the Carthaginian Empire, 1817. Oil on canvas, 171×241 cm. London, Tate Gallery. The critics did not judge it favourably when it was first exhibited at the Royal Academy in 1817. Ruskin himself was disappointed by it.

San Giorgio from the Dogana, Venice: Sunrise, 1819. (See *ill.* p. 15). Watercolour, 25.6×30.33 cm. London, British Museum. Turner was a master of watercolour painting, having learned the technique from J. R. Cozens, one of the greatest English watercolourists. Turner's predilection for this kind of painting can easily be understood with reference to his ideas about landscape, in particular his ideas on the problems of light and shade. Painting in watercolour, with the transparency and fluidity it offers, was the perfect medium for the representation of light. In fact, Turner was often accused of using oils exactly as if they were watercolours. There was also a practical reason for his preference: with watercolour Turner could colour his sketches at once, with the subject still in front of him, building up an accurate and spontaneous framework which he would later elaborate in oils in his studio. Watercolour also demanded bold, synthetic painting according to the canons of the picturesque style.

This picture of Venice, so limpid and translucent, is a good example of the boundless opportunities for expression that this kind of painting afforded.

28-9 George IV at a Banquet in Edinburgh, 1822. Oil on panel, 67×90 cm. London, Tate Gallery. Turner travelled constantly, and never stopped making notes and sketches; in 1822 he found himself in Edinburgh when the Royal Yacht sailed into Leith harbour on 14 August, and this painting was the result of his seeing the royal procession; he made other sketches of it as well. His extraordinary virtuosity can be seen already in all its main characteristics (note the footman in the foreground). The treatment of the light is interesting; it is diffused from within the painting itself.

Edinburgh Castle, 1822 (illustration in black and white pp. 10-11). Watercolour. London, British Museum.

30-1 View of Orvieto, 1828. Oil on canvas, 91.5×122 cm. London, Tate Gallery. This was painted in Rome in 1828 and exhibited, with *Attilius Regulus* and the *Vision of Medea*, to connoisseurs, critics and artists working in Rome at the time. The reaction was not encouraging, nor did it arouse much enthusiasm when it was presented in London at the Royal Academy. Nevertheless it is a very fine painting, and as Carandente observed, ' the extraordinary interpretation of the Umbrian landscape, in the golden light of the afternoon, is absolutely original and at the same time true to the almost unbelievable beauty of the place '.

32 The Promenade at Nantes, c. 1830. Watercolour, 14×19 cm. London, British Museum. This delicate sketch anticipates certain of the genre paintings of the impressionists, so often concentrated on the colourful life of the boulevards.

33-4 Saumur, c. 1830. Watercolour, 14×19 cm. London, British Museum. Typical example of a painting inspired directly by Turner's travels. The variety of the details which divert Turner's attention from his central theme is interesting.

35-6 Petworth Park: Tillington Church in the distance, c. 1830. Oil on canvas, 65×147 cm. London, Tate Gallery. Turner often stayed at Petworth as the guest of his friend and patron Lord Egremont. Here he found perfect tranquillity when his calumniators in London grew too much for him. This unfinished painting, showing the park seen from the great house at dawn, with hounds running on the left-hand side and a group of deer on the right, is a sketch for one of four panels painted by Turner (in about 1830) for one of the rooms in Petworth. As can be gathered from the peace and poetic serenity of the painting, Turner's visits to Petworth were some of the happiest times of his life. They were peaceful interludes from which he drew great strength and renewed energy

for painting. Some of his greatest experiments with colour and light were painted at Petworth (*Music Party, Petworth, Interior at Petworth* etc.), in the freedom and silence of natural surroundings.

37-8 Music Party, Petworth, c. 1835. Oil on canvas, 122×99 cm. London, Tate Gallery. Finberg proposed 1830 as the date of this unfinished painting: Turner certainly stayed at Petworth during that year. The National Gallery *Catalogue of the British School* (1946) proposes 1837 for the date of *Interior at Petworth*, which is stylistically very close to this picture; this would mean that it was painted during Turner's last visit to Petworth, just before Lord Egremont's death in 1837. Each object is surrounded by a light halo of colour; the figures are placed rhythmically, almost musically. The violence of the colours does not detract from the serene, contemplative atmosphere of the painting.

39 A Room at Petworth, c. 1835. Gouache on blue paper, 14×19 cm. London, British Museum. See preceding note.

40-1 Interior at Petworth, c. 1835. Oil on canvas, 91×121 cm. London, National Gallery. Unfinished work, painted when Turner was staying with his friend and patron George Wyndham, third Viscount Egremont, at Petworth. In this painting, as in the others of the series, Turner is making a study of indoor light. Here the light which comes in through the windows is so strong that it obliterates the outlines of the objects in the room. This, and the fact that it is unfinished, explain the apparent chaos. Yet, as Ruskin observed, there might be another explanation. Turner could not only easily endure disorder, he actually enjoyed it, and went out of his way to find it in places such as Covent Garden after the market was over for the day. His paintings are frequently filled with it, from one side to the other; the foreground is distinguished from other parts by the objects scattered about in natural disorder.

42-3 Staffa: Fingal's Cave, 1832. Oil on canvas, 91.5×122 cm. London, Gavin Astor collection. A marine landscape typical of Turner's mature style. He has by now abandoned accurate description in favour of enquiry into atmospheric values. The smoke from the steamship mingling with the clouds and the waves gives the picture a strong sense of movement.

44-5 Venice: Bridge of Sighs, Ducal Palace and Custom-house, Canaletto Painting, 1833. Oil on panel, 51×81 cm. London, Tate Gallery. This was the first view of Venice that Turner exhibited, painted from sketches made during his visit in 1819. The drawing is scrupulously realistic. The figure of Canaletto, in Oriental dress, painting a canvas which is already framed in an extravagant baroque frame, is a blatant homage to Turner's master. The influence of Canaletto's style can be detected in the drawing of the Venetian architecture. The painting was bought by the collector Robert Vernon for the sum of 200 guineas, and was later donated to the National

Gallery in 1847. It is quite possible that Turner's frequent re-working of Venetian themes may have owed something to his involvement with Byron's poetry. His Venetian pictures were highly successful, commercially as well as artistically, and it has been said that Turner was not very pleased by the sudden public favour, remarking that if his scabs pleased the public, they must pay for them. Between 1835 and 1840 Turner did the remarkable sketch (in gouache and chalks on coloured paper), now in the British Museum, entitled *Venice: the Salute and the Custom-house, night*. Here Venice appears as a dream city, a fantastic vision. Sketches such as these reveal the painter's most intensely lyrical moments.

46-7 A Fire at Sea, c. 1834. Oil on canvas, 174×224 cm. London, National Gallery. Turner was often blamed for his preference for highly theatrical subjects: this large imaginative composition could be his justification, if one is needed. The picture shows one of Turner's favourite scenes (a storm), and the drama is portrayed very violently and expressively. In a sea tossed by the fury of the wind, with fire and water mingling in a great cyclone, the bodies of the shipwrecked sailors follow the sea's forceful drift and are thrown towards the sky or engulfed in the gaping pit of waters. Here again we have man's terror and impotence in the face of the blind forces of nature. Turner felt this emotion very forcibly, and works like this one were painted directly from his experience of such moments; they have no moralistic intention. The colours and composition recall the stylistic usages of the baroque.

48 Study for the Burning of the Houses of Parliament, 1834. Watercolour, 23.4×32.1 cm. London, British Museum. See the note to the following painting.

49-50 The Burning of the Houses of Parliament, 1835. Oil on canvas, 94×123 cm. Cleveland Museum of Art (John L. Severance collection). There was a tremendous fire in the Houses of Parliament in October 1834. Turner, who had just returned to London from Petworth, made hurried sketches of the scene from various different aspects: later he worked on them in his studio. This painting is a version of the fire seen from the southern end of Waterloo Bridge. The huge mass of flames in the middle, which lights up the sky and water with a sinister glow, red and orange against the black, greys and coppery greens, creates an extremely dramatic effect. The *Spectator* reported that the explosion of light at the heart of the flames, and the fairy-tale pillar of fire which lights up all the buildings which surround it, were ' incomparably realistic ' and asked what other painter could rival the underrated Turner in the clarity of his colours.

51-2 Norham Castle, Sunrise, 1835-40. Oil on canvas, 90×120 cm. London, Tate Gallery. The sketch illustrates Turner's theory that bright light consumes and destroys everything, re-assimilating objects in its own impalpable atmosphere and infinite space. This

picture is an interesting example because it contains some of the central tenets of Turner's theory of painting: in the first place, the space is identified by a gradation of the substance of the objects from front to back; the objects in the foreground, summarily defined, grow vaguer as they recede into the rarefied atmosphere of the distant mountains. Secondly, the light is analysed through the effect it has on the objects. Thirdly, the description of atmospheric effects is by Turner's exclusive method, the new dimension of space-light. His palette opens out in a series of half-tones, mixed and merged in vaporous mists. Behind a castle, barely sketched in and surrounded by a blue cloud, the sun rises in an opalescent sky. A russet cow is drinking at the brink of a river which flows on until it merges magically with the sky. Turner saw Norham Castle, on the Tweed, only twice, the second time in 1801. This picture is perhaps from memory, yet it is still fresh and spontaneous. An earlier version in watercolour was shown in the Royal Academy in 1799, and three other versions, also in watercolour, were painted between 1820 and 1833.

53-4 The Parting of Hero and Leander, 1828-37. Oil on canvas, 146×236 cm. London, Tate Gallery. A large historical painting, planned with violent contrasts of tonal values. Rothenstein observes correctly that without its complex colour scheme, a painting such as this one would be little more than an elaborate back-cloth. Thanks to the colours, the subject changes into a sombre vision of the stormy energy of the sea and the sky, overpowering the feeble hopes and desires of ephemeral humanity.

55-6 Rocky Bay with Classic Figures, c. 1828. Oil on canvas, 90×123 cm. London, Tate Gallery. The plan of this painting betrays an interest in the picturesque. The sea, deep emerald-green and with an almost unbroken surface, skirts round the base of a rock which forms a natural arch, and the arch is pierced by a ray of sunlight which shines obliquely into the water, lighting up the depths of the sea. Under a clear sky boats can just be glimpsed in the bay and vague figures on the beach. It seems almost as if Turner were testing the perceptiveness of the onlooker, seeing if the tiniest atmospheric detail would be noticed. This is one of the most typical paintings of Turner's maturity, free from any classical influence.

57-8 Bridge and Tower, c. 1840. Oil on canvas, 91.5×122 cm. London, Tate Gallery. The subject of this magnificent canvas, no. 2424 in the Tate Gallery catalogue, has recently been identified by Giovanni Carandente as the bridge and tower near Spoleto. In the catalogue of the exhibition in Rome in 1966, Carandente records that Turner 'left Rome on 3 January 1829 and travelled to Turin via Spoleto, Foligno, Macerata, Ancona and Bologna . . .' Since the proportions of the arches of the bridge are not completely faithful to their model, it is possible that Turner painted the picture from a quick sketch made on the spot. In the foreground the dark bulk of a tree is a firm point of reference; the rest of the canvas is

pervaded with glancing light. The 'Turnerian mystery' which Ruskin mentioned in his *Modern Painters* is particularly evident in this painting. C. De Martino, reviewing the Roman exhibition (in *Estro*, no. 1-2, 1967) noted that in this work ' Turner's originality and sensitivity are revealed at their highest level. The entire surface shares the brilliant sunlight, which drives away the last remaining clouds. The bridge can only just be seen, and looks weightless, almost without substance, transfigured by the light which bathes the whole atmosphere. The more distant objects seem to dissolve into space. I know no other landscape painter, including Ruysdael and Claude Lorrain, who could have conveyed the scene so tellingly on canvas, making it so realistic and yet so ethereal. '

59-62 Sailors unloading Coal by Moonlight, 1835. Oil on canvas, 92×122.4 cm. Washington, D. C., National Gallery of Art (Widener collection). Against a calm sea silvered by the light of the moon, the men work with febrile energy. The sparkling moonlight contrasts with the warm light given off by the boats grouped together in the background. The two tonalities – cold from the sky, warm from the boats – mingle on the smooth surface of the sea and create an atmosphere of rare equilibrium. Ruskin, in his analysis of Turner's use of colour, came to the conclusion that it was the opposite of Rembrandt's: Rembrandt uses colour darkly, tending towards darkness and to resolving everything into shadow, whereas Turner uses it lightly, always seeking the maximum amount of light and resolving everything into light.

63-4 The Grand Canal, Venice, 1835. Oil on canvas, 91×123 cm. New York, Metropolitan Museum of Art (Cornelius Vanderbilt bequest). In this painting, first exhibited in 1835, the colour values and the drawing are of equal importance, and both are based on accurate observation; the painting is clearly the outcome of Turner's apprenticeship in his youth to painters who used this style. On the right is the church of Santa Maria della Salute, on the left St Mark's Campanile and the Doge's palace. The influence of Venetian painters, in particular Canaletto, is obvious. The spontaneity and fresh transparency of the colours also bring back memories of Guardi.

65-6 'The 'Fighting Téméraire' tugged to her last Berth to be broken up, 1838. Oil on canvas, 90×120 cm. London, National Gallery. In 1838 the decision was taken to break up the glorious *Téméraire*, the pride of Trafalgar (1805). The painting is clearly based on a sentimental feeling for the ship, but is none the less valuable for that reason. Turner was very attached to it and refused many offers to sell; he exhibited it at the Royal Academy in 1839 with the moving caption ' the flag which braved the battle and the breeze, No longer owns her '.

67-8 The Slave-ship, 1839. Oil on canvas, 91×122 cm. Boston, Mass., Museum of Fine Arts (Henry Lillie Pierce Fund). This painting represents the climax of Turner's middle period. It was

exhibited for the first time in 1840 at the Royal Academy with a descriptive title: 'Slavers throwing overboard the dead and dying – Typhon coming on'. The dramatic intensity of the painting (the dying men thrashing about in the sea, lit up by sinister gold and red flashes of light, are painted with the crudest realism) inspired Ruskin to make admiring comments about it: he found in it 'the wisdom of a lifetime', and regarded it as having been inspired by 'the highest motives: by the majesty and infinity of the open seas, deep and boundless'. In spite of this, and praise from well-known writers such as Thackeray, there was also plenty of opposition to the painting. The painter's attention seems to be focussed on atmospheric effects, yet without detracting from the dramatic strength of the painting. The boldness of his method of representation allows him to use an extraordinarily individual and modern style.

69-70 Venice: the Piazzetta from the Water, c. 1835. Oil on canvas, 91×122 cm. London, Tate Gallery. Of the paintings Turner completed after his three trips to Venice, this is certainly one of the least faithful to the style of Canaletto and Guardi. This shows that by now his maturity is blossoming: his pictorial values are entirely his own and perfectly worked out. Reviewing the exhibition at the Royal Academy in 1844 the *Spectator* called his architecture in two views of Venice 'too evanescent for anything but a fairy city'. Undoubtedly his painting has its magical aspects, particularly now that he is entirely free from any extraneous influences; his colour has lost all pretence of realism and convention, sticking to an ethereal scale of greys and blues, burnt Sienna and yellows, Veronese and emerald green. His painting relies on mystery, and draws on the same basic sources as Venetian painting. His technique allows him to combine the expressive qualities of oils with the freshness and transparency of watercolours. This painting and another on the same theme were for years regarded as too unimportant to be exhibited: Turner hung it in his private gallery (the famous Turner Gallery, designed to the artist's own plan and installed above his house at 64 Harley St), where its condition deteriorated because of damp. It was part of the Turner Bequest, and was exhibited for the first time, after cleaning, only in 1955.

71 Stormy Sea, c. 1835-40. Oil on canvas, 91.5×122 cm. London, Tate Gallery. This is a fine example of Turner's mature style, and illustrates his power to catch an atmosphere in a few brush strokes. The painter demonstrates in these sketched notes that his starting point is not emotion but perception; his perception is isolated and submitted to a careful analysis, which is then translated into dazzling masses of light, and vaporous, changing solid patches. There is absolutely no indication of the whereabouts of any solid objects here: everything is absorbed into sea and sky.

72 The Yellow Ehrenbreitstein, c. 1841. Watercolour, 24.1×28.3 cm. London, British Museum. This is the yellow version of the pink

Ehrenbreitstein. The experiment demonstrates Turner's freedom from the fetters of convention and his desire to study pure visual values.

73-4 The Landing of the Pamphilus, c. 1842. Oil on canvas, 101×143 cm. London, Tate Gallery. A characteristic example of Turner's ecstatic use of transparencies and vapours. It is well known that his work was based on a search for luminous diffusion through space, which he found first by studying the effect of light on objects, and later progressively as an entity on its own account. It is hardly surprising that the then current taste for classical survivals, based on the public's appreciation of Constable's very solid paintings, should have found these evanescent images, which according to *The Athenaeum*, 1841, were the 'fruits of a diseased eye and reckless hand', little to its taste.

75-6 Snowstorm, 1842. Oil on canvas, 90×120 cm. London, National Gallery. This painting, which is one of the most characteristic works of Turner's mature style, was shown in 1842 at the Royal Academy with this rubric: ' Snowstorm: steam-boat off a harbour's mouth making signals in shallow water, and going by the lead '. This detailed explanation of a painting in its title is quite normal with Turner, who may have realised the novelty of his representation of events and the difficulty that could be experienced interpreting them: he was always careful to give an adequate clue to the component parts of the work. A note in the catalogue informs us that the author did in fact experience a storm like this on the night that the Ariel set sail from Harwich. Turner refers to his having been lashed to the mainsail in order to have a better view of the storm he wanted to paint: ' I did not expect to escape '. He was sixty-seven years old at the time. Besides the purely aesthetic value of the painting, the episode serves as a proof that Turner's paintings were not based on visionary experience; in fact the stronger the impression made upon him by a physical experience, the more vivid was his subsequent record or revival of the scene in a painting. This painting was labelled ' soapsuds and whitewash ', an instance of the gulf between contemporary criticism and Turner, with his passion for authentic drama and his longing to create a new kind of realism, realism of sensation. Ruskin praised this painting, calling it one of the vastest representations of the sea in motion, and of clouds and light, that had ever been put on canvas, even by Turner himself.

77-8 A Venetian Scene (St Benedetto, looking towards Fusina), 1843. Oil on canvas, 61×92 cm. London, National Gallery. This is almost certainly a view of the Giudecca, in which case the title is incorrect, as the church of San Benedetto is in the centre of Venice near St Mark's. It is probable that Turner's topographical notes were muddled, especially as we know that he painted from memory using sketches made on the spot. He continued to paint Venetian scenes until 1846, but his last trip to Venice was in 1840. This painting is a particularly fine example of his mature style, when he finally abandoned the search for realistic landscape to

concentrate his attention exclusively on the interplay of colour and light. Here Turner is intoxicated by the mixture of reality and memory, imagination and dream, and he conveys his feeling on canvas using all the technical weapons at his command: all substance has been extracted and replaced by airy and vaporous forms, bathed in light. The gondolas, the figures, the houses and the landscape in the background have lost their concrete reality entirely, and float in an exquisite sea of yellows, greys and browns.

79 Shade and Darkness: the Evening of the Deluge, 1843. Oil on canvas, 77×77 cm. London, Tate Gallery. A fantastic vision painted at the same period as the series of sea monsters. Turner worked on the theme of imagined seascapes, and some of the profoundest paintings of the last ten years of his life are of the sea. It represented for him a way of re-capturing the dimension which exists between dream and memory, and at the same time of exploring remote regions of his being. He is in close communication with nature on a mystical and pantheistic level. This imaginary vision is developed in the twin painting (*pl. 80*), painted during the same year: here the dark night full of monsters is replaced by a golden vision, almost blinding in its brightness.

80 Light and Colour (Goethe's Theory): the Morning after the Deluge, 1843. Oil on canvas, 77×77 cm. London, Tate Gallery. Even though this canvas is the exact opposite of *pl. 79*, it is remarkable that the 'Light' which represents the triumph of light over darkness should not be a natural light. It must therefore be a kind of spiritual light, stemming from the depths of Turner's imagination, and in opposition to the natural and observed forms of nature.

81-2 Van Tromp returning after the Battle off the Dogger Bank, 1843. Oil on canvas, 91.5×122 cm. Englefield Green, Surrey, Royal Holloway College. Turner exhibited this painting at the Royal Academy in 1844 with an ironical rubric referring to the episode in which the seventeenth-century Dutch admiral who gave his name to the ship, in order to obey his masters (who were giving him orders), shipped 'a sea, getting a good wetting'.

83-4 Rain, Steam and Speed - the Great Western Railway, 1844. Oil on canvas, 91×122 cm. London, National Gallery. Turner was always a spokesman for the modern concept of the sublime, which was supposed to replace spiritual painting, the picturesque and the classical notion of the sublime. The search for the sublime, as Turner interpreted it, was called in question by Constable and his straightforward figurative painting; Turner's search for the pure value of light was directly opposed to Constable's ideas of a modern vision. Turner's research came to a climax in this painting of 1844; the train appears and disappears in the wind and rain like a mythical beast of modern times, at war with nature and regarded by Turner with detached melancholy.

85 Baden, Switzerland, 1844. Watercolour, 22.8×32.4 cm. London, British Museum. Although this was painted in 1844, it exemplifies the kind of analytical drawing reminiscent of the topographical period of Turner's youth. The scene is recorded exactly as it was at the moment Turner saw it. The mountain behind the city, in the background, looks like a white, transparent piece of lace, stuck on to the sky. The foreground is sketched with tremendous bravura and aplomb.

86-7 The Angel standing in the Sun, 1846. Oil on canvas, 77×77 cm. London, Tate Gallery. Probably painted in Turner's studio, as it has no reference to external details. The painter's whole attention is concentrated on the painting of light effects. This completely single-minded research involves the whole picture and dispenses it from the normal requirements of drawing or composition. Notable is the way the brilliant light from the sun, all-pervading, has consumed all efforts at drawing, pulling everything into its concentric circle of blazing light. This vision of objects at the centre of concentric spheres occurs in other works of this period (i.e. *Light and Colour, pl. 80, Snowstorm, pls 75-6,* etc.).

88-9 'Hurrah! For the whaler Erebus! Another fish!' 1846. Oil on canvas, 89×119 cm. London, Tate Gallery. The composition was based on a description of whaling by Thomas Beale, written in 1839. It was shown at the Royal Academy in 1846 with two other paintings of the same subject. Between 1844 and 1845 Turned filled an album with what he called whaler sketches, which are all of whales and sea-life. At this time Turner was tremendously impressed by the tales of Polar travellers (there is a typical example of this, *Dawn, with a Sea Monster,* painted 1845). This painting is divided into two nuclei: on the right the whale ship is anchored to the bank and surrounded by small boats full of fishermen. On the left other boats with waving figures. In the centre the brightness of the light seems to have dissolved all tangible objects.

Portrait of Turner (illustration in black and white p. 5). Pencil on card. London, Royal Academy. Drawing by George Dance, signed and dated 31 March 1800 in the bottom right-hand corner.

Turner painting one of his pictures (illustration in black and white p. 24). Caricature which appeared in *The Almanack of the Month* in June 1846.

A Sketch of Turner as a landscape painter (illustration in black and white p. 27). Pen drawing by C. R. Leslie in a letter, now in the collection of A. L. Gordon.

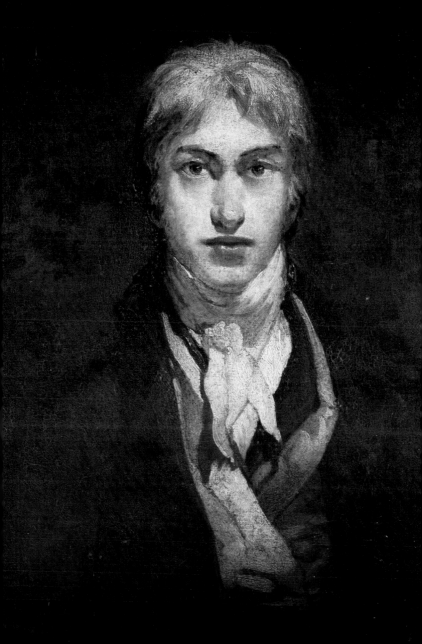

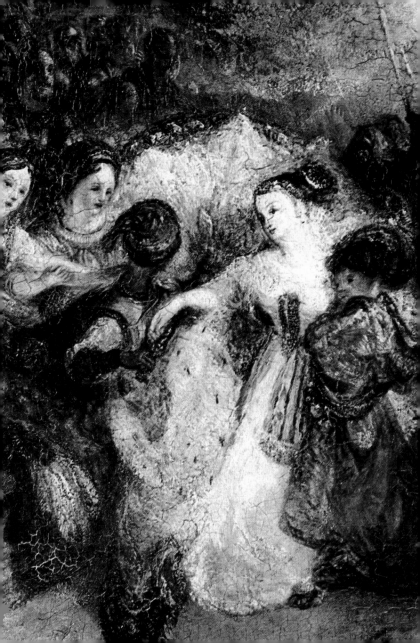

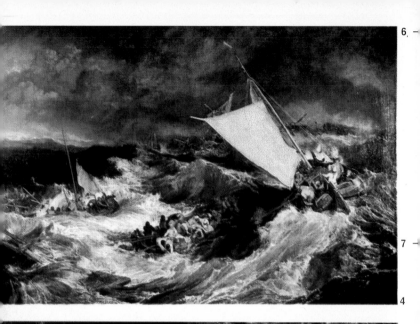

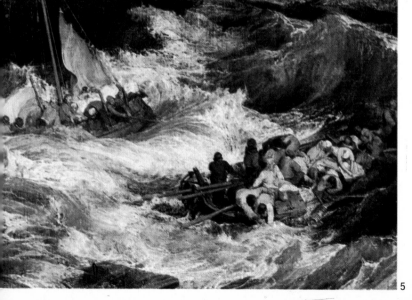

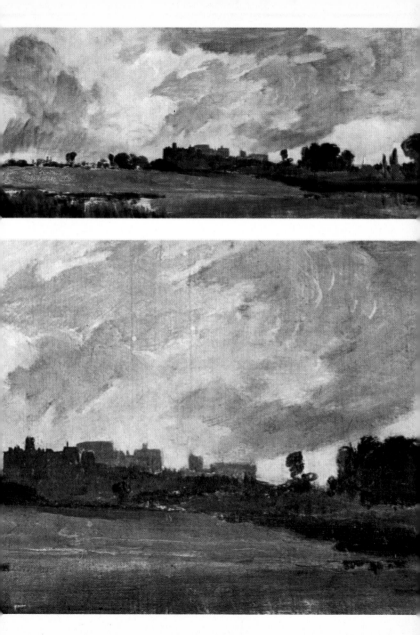

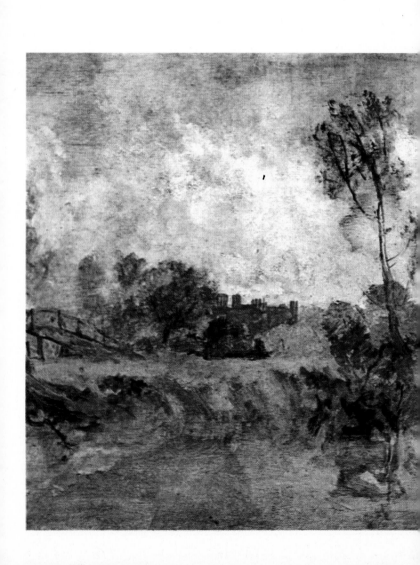

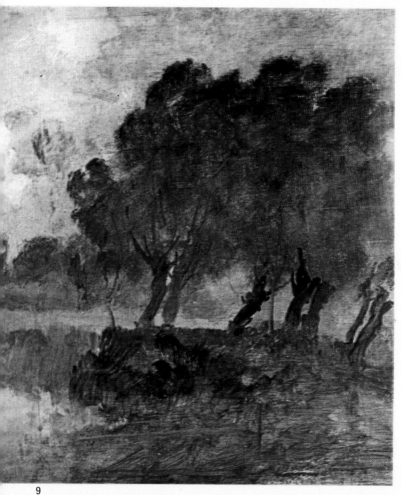

9

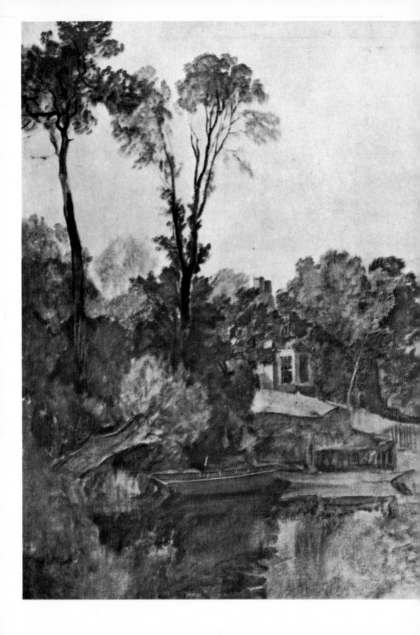

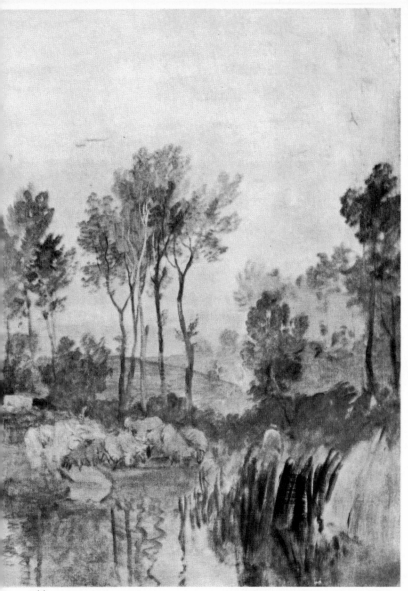

11

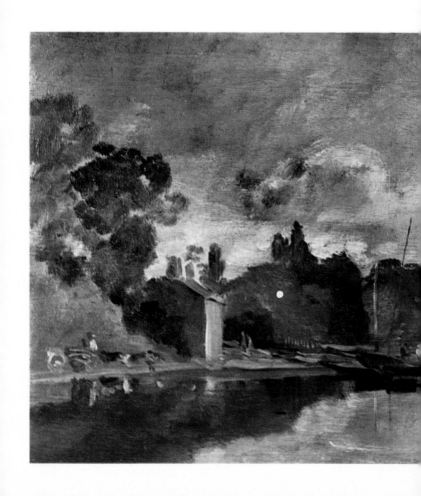

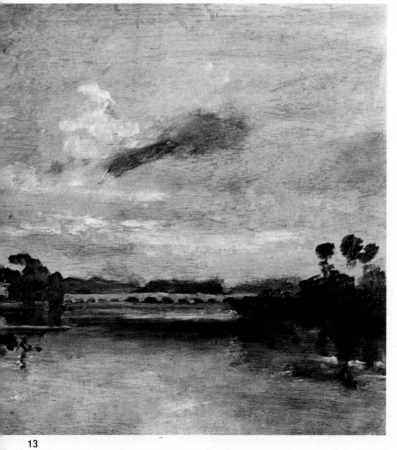

13

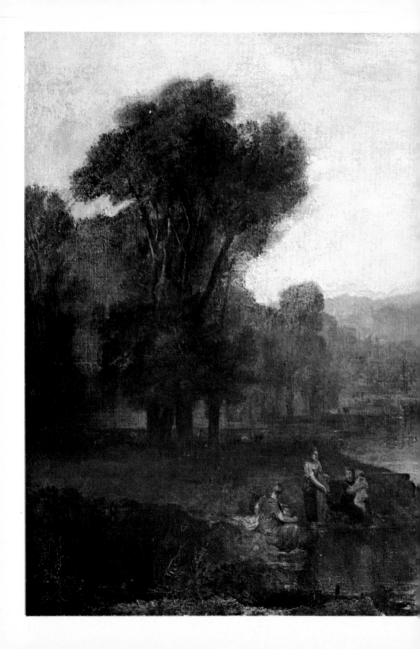

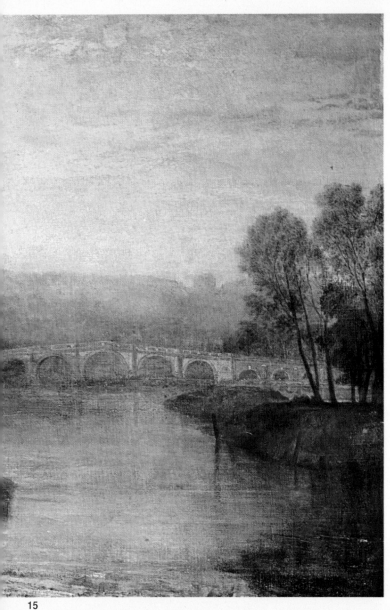

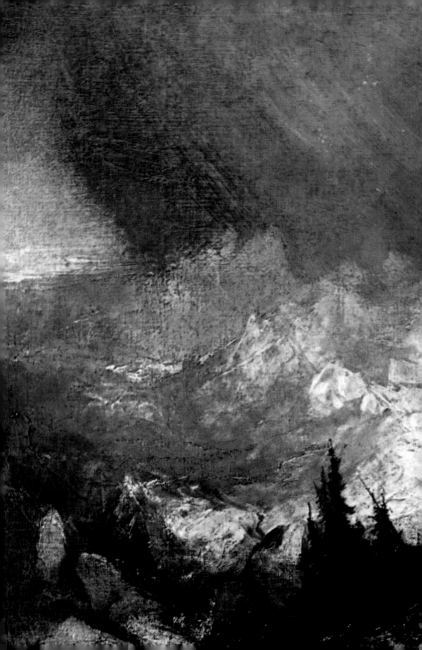

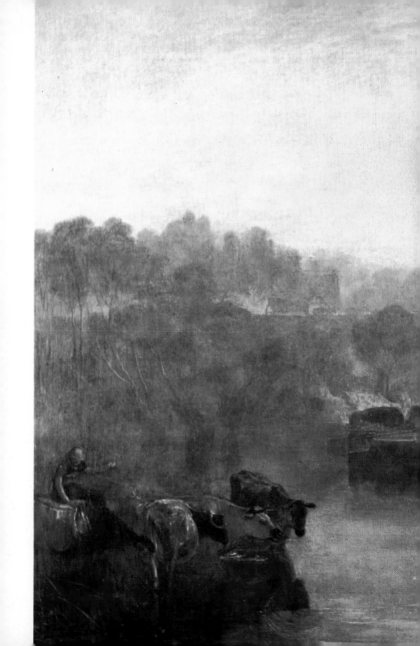

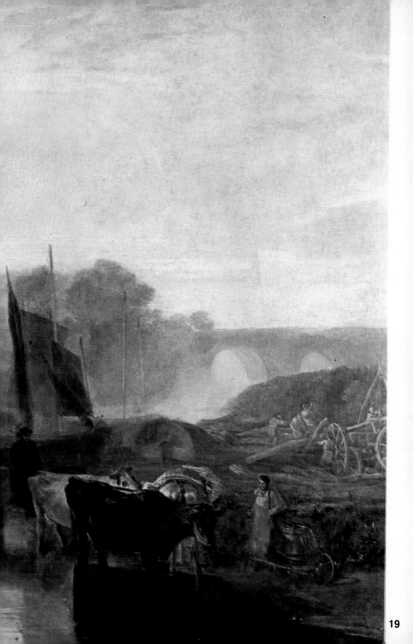

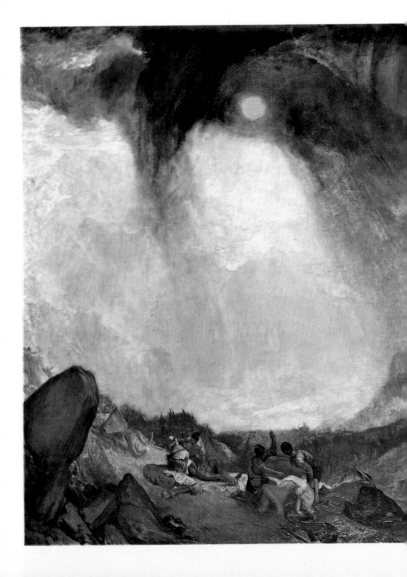

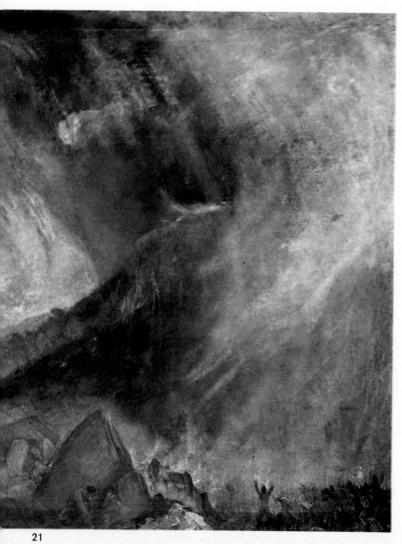

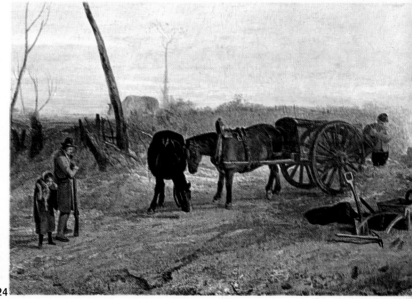

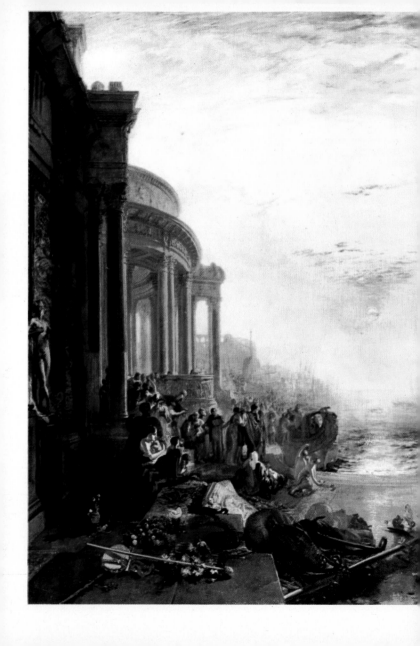

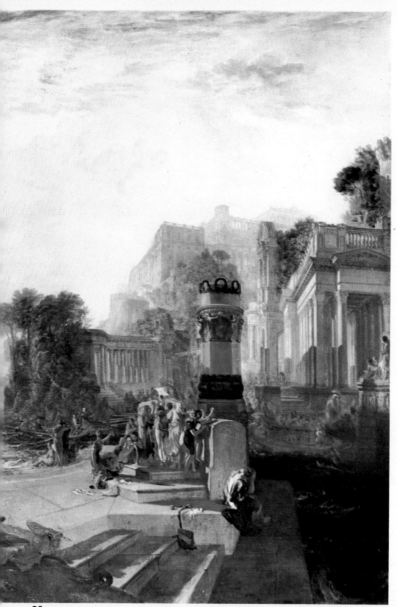

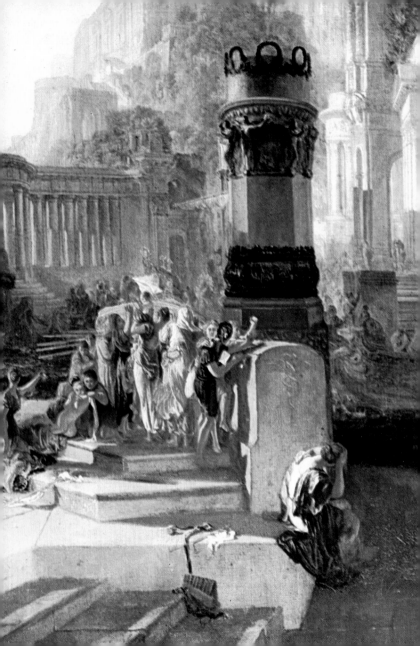

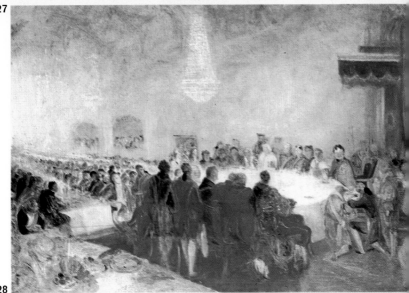

28

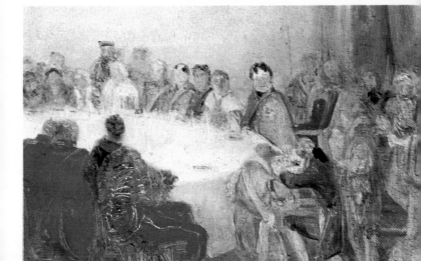

29

34 –

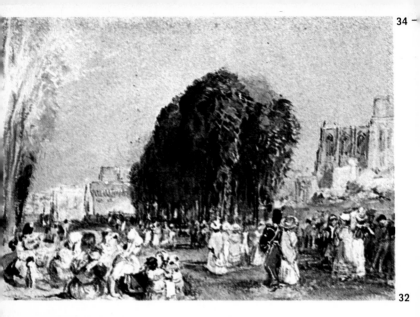

32

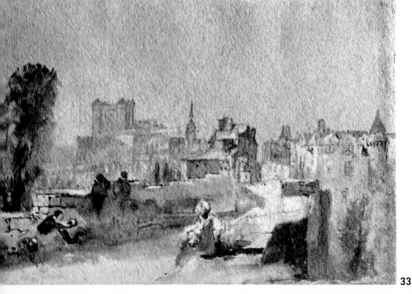

33

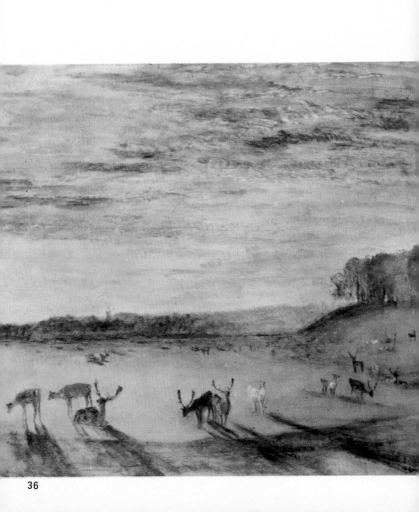

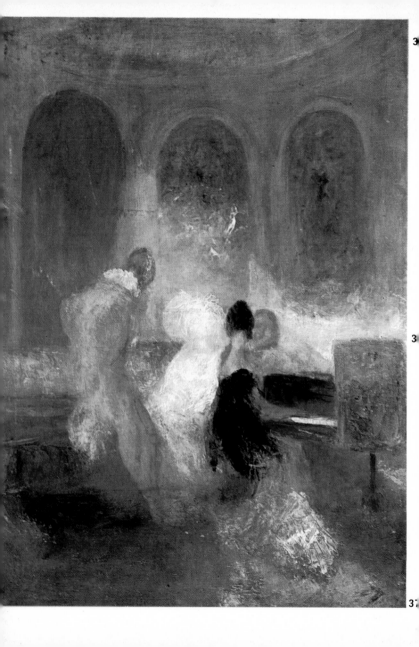

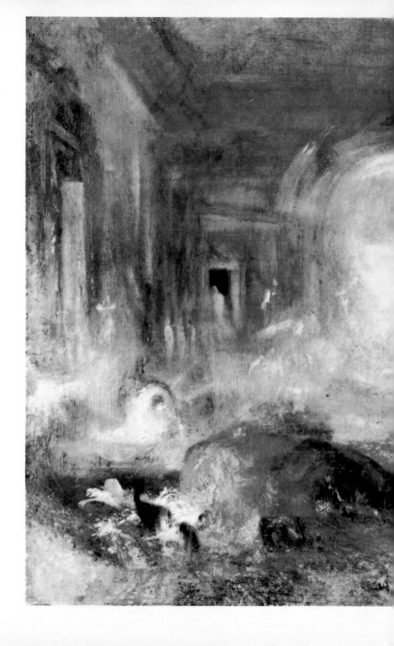

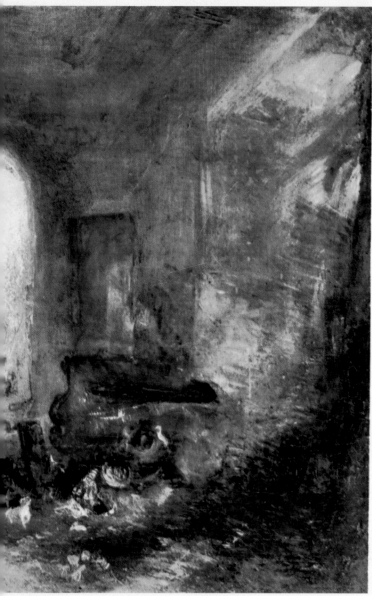

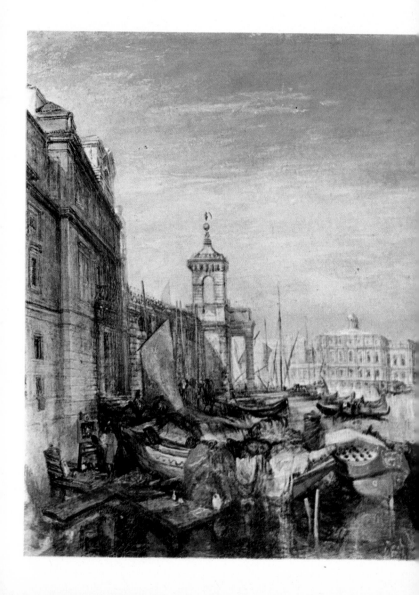

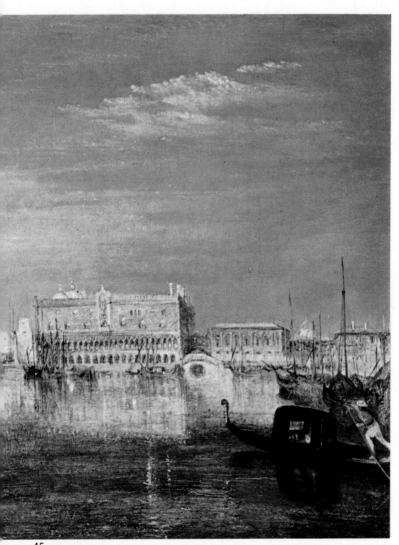

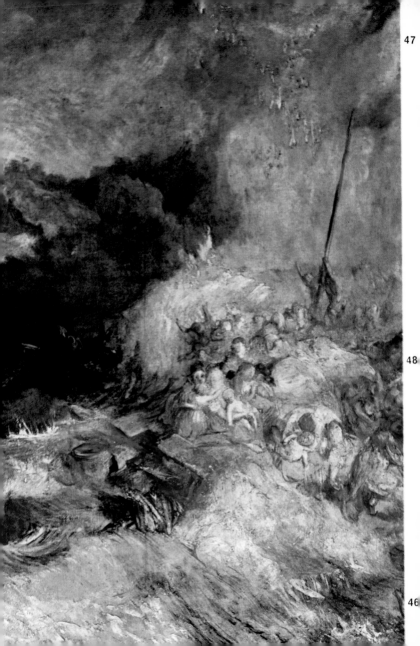

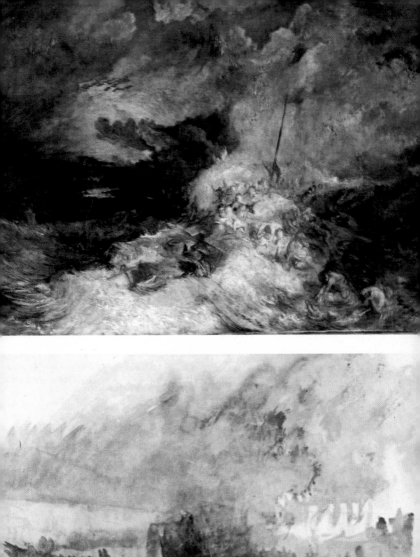

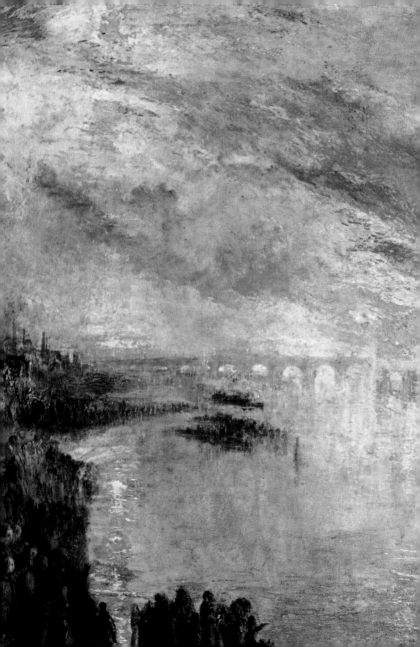

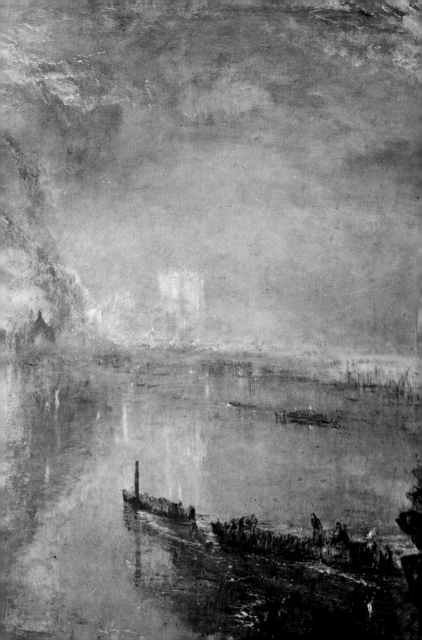

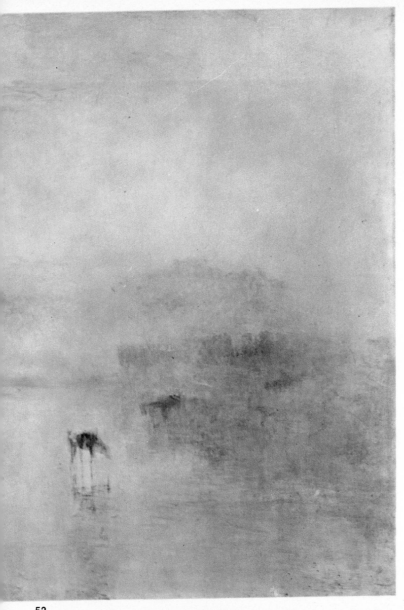

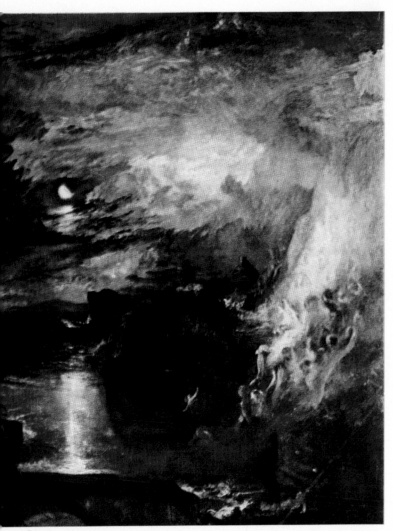

54

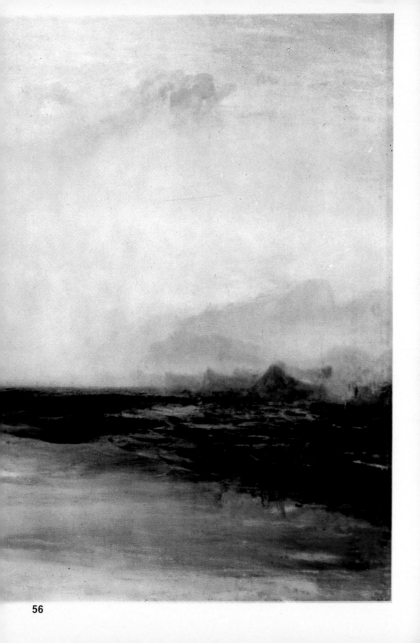

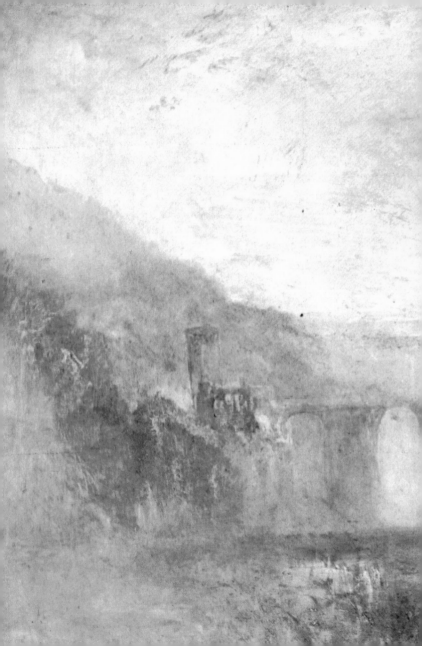

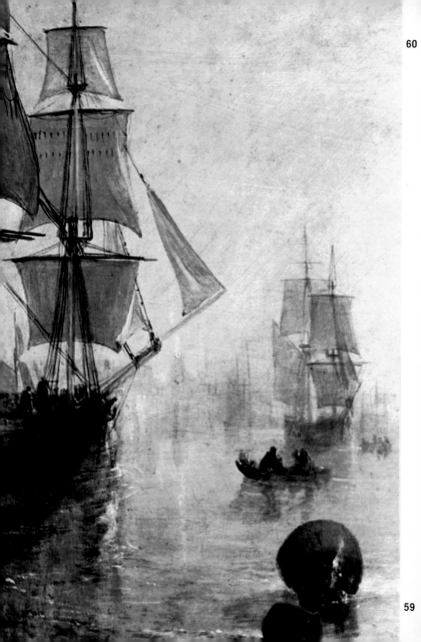

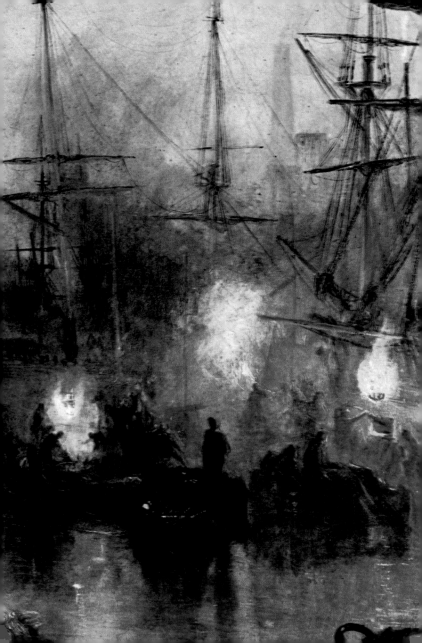

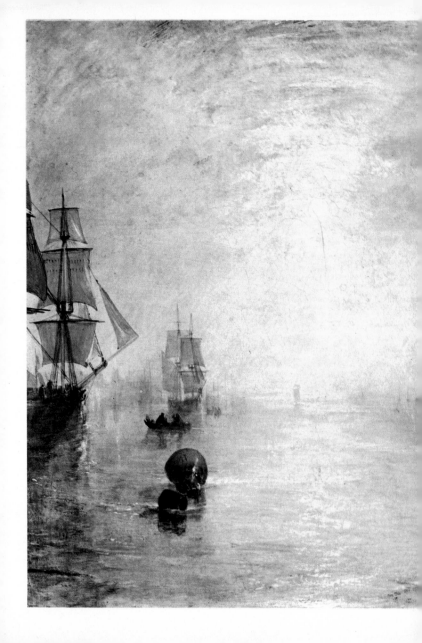

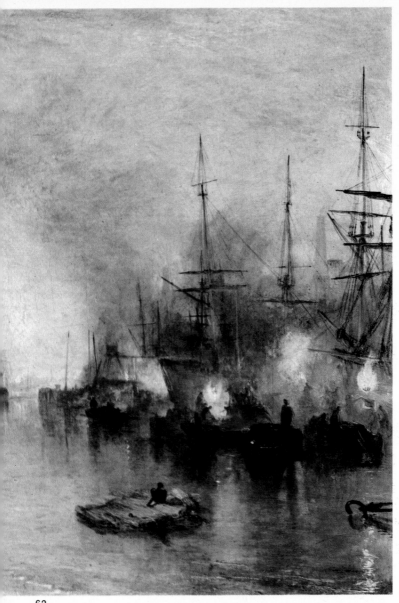

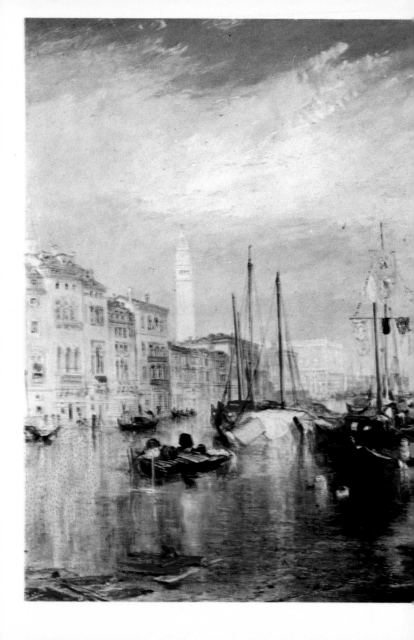

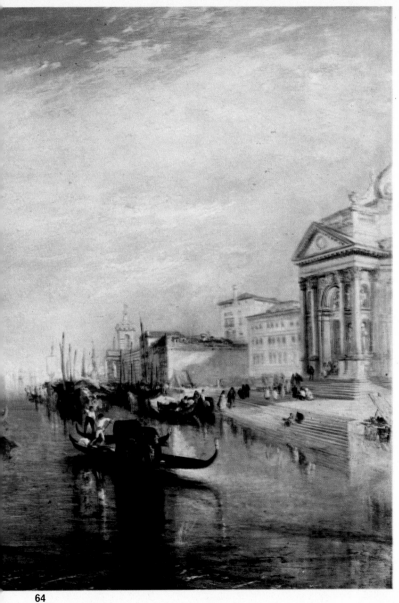

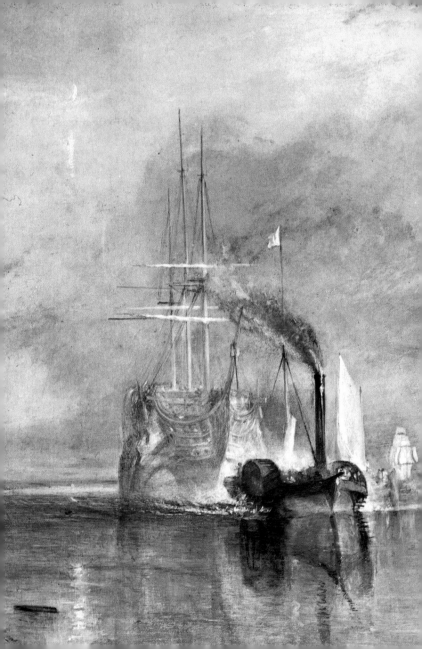

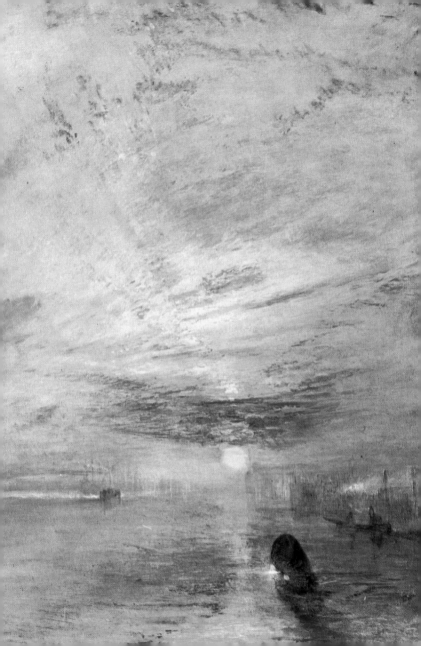

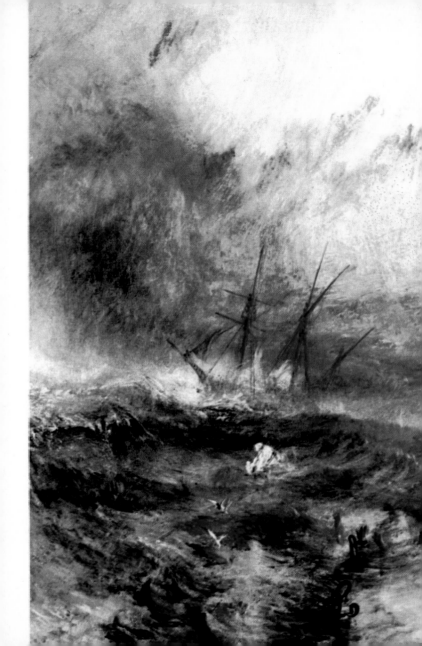

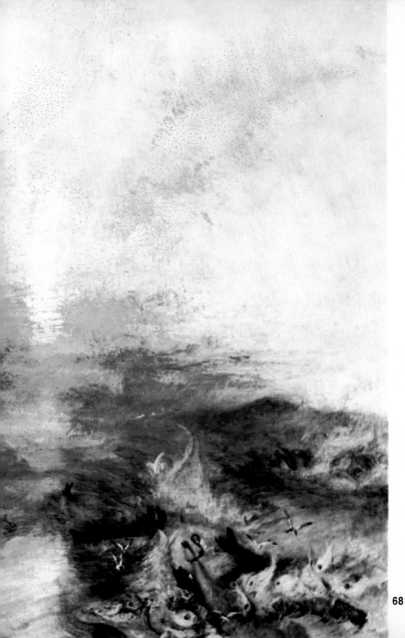

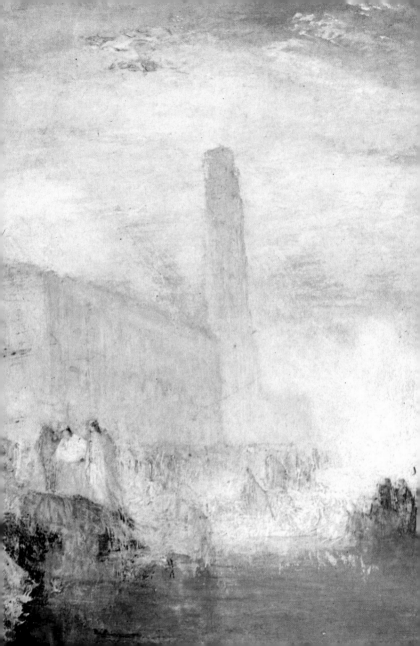

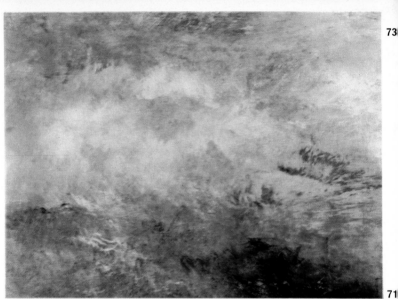

73

71

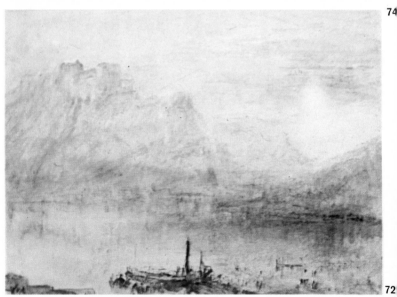

74

72

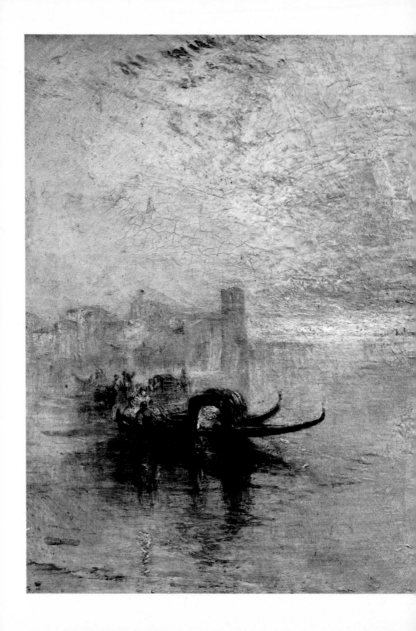

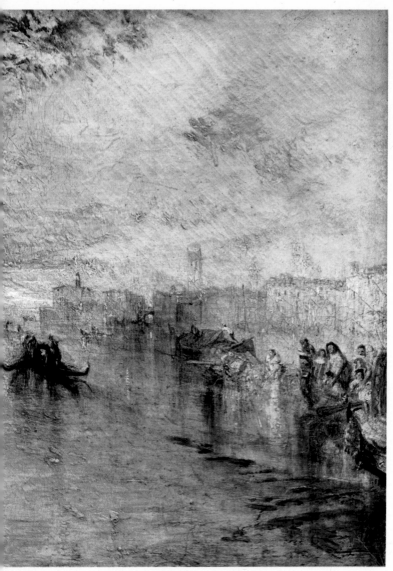

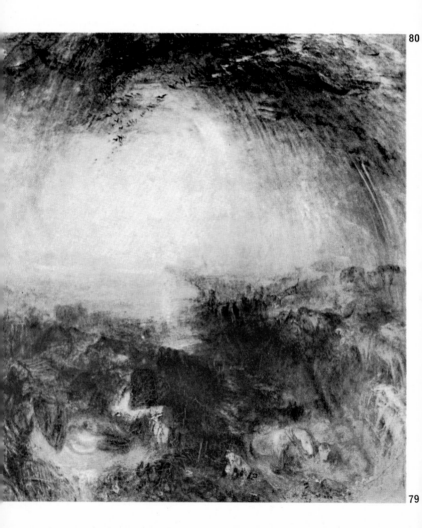

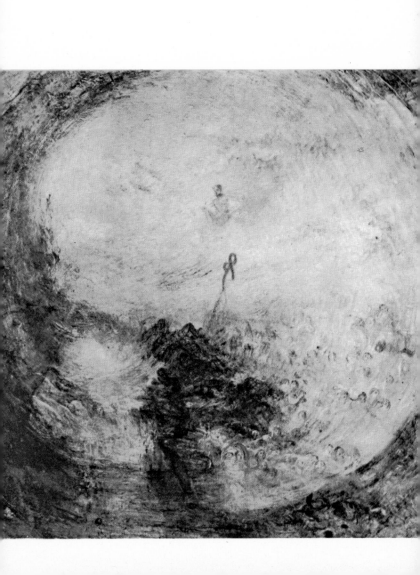

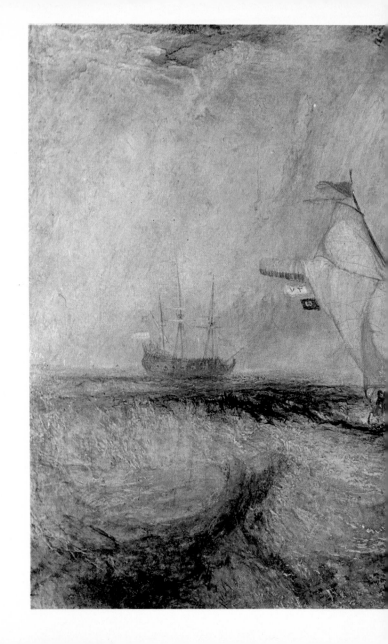

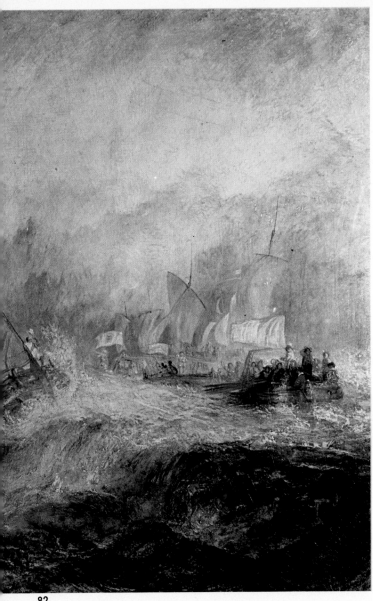

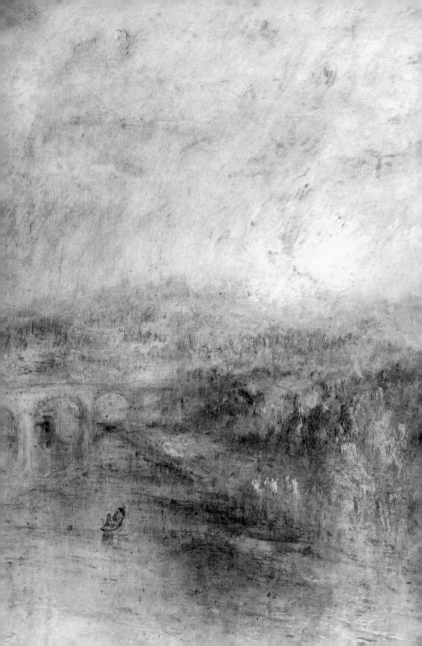

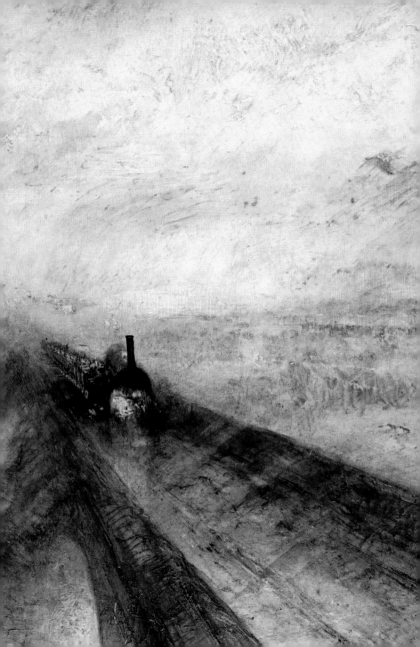

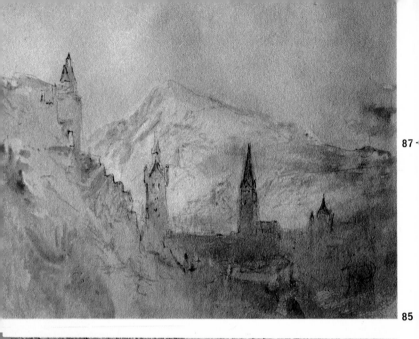

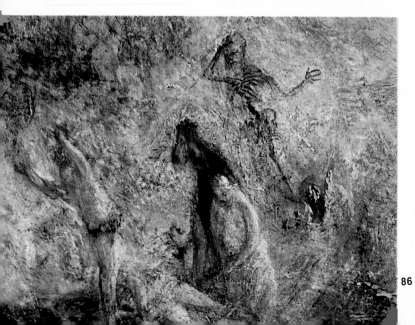

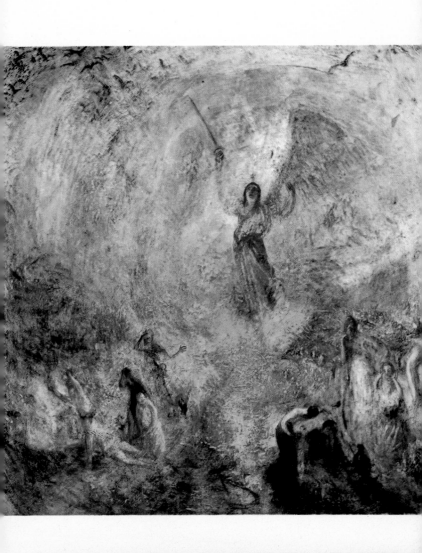

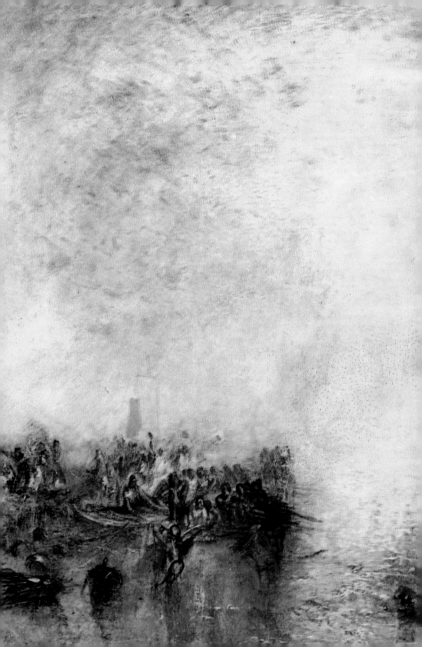